African, Pacific, and Pre-Columbian Art

in the
Indiana University Art Museum

Essays by

Roy Sieber
Douglas Newton
Michael D. Coe

Organized by
Patricia Darish

Indiana University Art Museum
in association with
Indiana University Press
Bloomington and Indianapolis

A catalog prepared in conjunction with the installation
of the gallery of African, Pacific, and Pre-Columbian art

This catalog was made possible by a grant from
the National Endowment for the Arts

Design and Illustration: Brian Garvey
Editing: Linda Baden
Photography: Michael Cavanagh and Kevin Montague
Typography and Printing: Metropolitan Printing Service,
Bloomington, Indiana

Distributed by Indiana University Press,
Bloomington, Indiana 47405

Library of Congress Cataloging-in-Publication Data

Indiana University, Bloomington. Art Museum.
 African, Pacific, and pre-Columbian art in the
Indiana University Art Museum.

 "A catalog prepared in conjunction with the
installation of the gallery of African, Pacific,
and pre-Columbian art"—T.p. verso.
 Bibliography: p.
 Contents: The art of pre-Columbian America/
Michael D. Coe—Visual arts of the Pacific/
Douglas Newton—African arts/Roy Sieber.
 1. Art, Primitive—Catalogs. 2. Art—Indiana—
Bloomington—Catalogs. 3. Indiana University,
Bloomington. Art Museum—Catalogs. I. Sieber,
Roy, 1923- . II. Newton Douglas, 1920-
III. Coe, Michael D. IV. Darish, Patricia. V. Title.
N5310.8.U6B565 1986 709'.01'10740172255 86-81510
ISBN 0-253-30442-3 (Indiana University Press)
ISBN 0-253-20412-7 (Indiana University Press : pbk.)

Cover illustration:
detail, no. 157
Woman's Ceremonial Skirt
Kuba (Bushoong); Zaire
Raffia plain weave, raffia embroidery
and appliqué
L. 537.8 cm
84.57

Contents

Foreword

Within a few years of the gift from James S. Adams in 1955, which triggered the development of a general art museum collection, gifts from several other donors set the foundations for the future strengths of the museum. These included gifts in 1959 from Frederick Stafford, which created the basis for the collections of African, Pacific, and Pre-Columbian art covered by this publication.

In 1962 Roy Sieber joined the Department of Fine Arts faculty to teach African, Pacific, and Pre-Columbian art history. In addition to his innovative scholarship, he brought a connoisseur's enthusiasm for objects and a growing coterie of collector friends. Foremost among these were Raymond and Laura Wielgus, who made their first gift, a Costa Rican mace head, that year. Many gifts were to follow, until, in 1975, a decision was made of greatest importance to the museum: the commitment of the Raymond and Laura Wielgus Collection to Indiana. Few private collections of African, Pacific, and Pre-Columbian art are of such uniformly exceptional quality, marked by such authoritative connoisseurship.

Encouraged by Roy Sieber, many people have given generously to the collections over the years. Particular credit for their gifts and support should be given to Ernst and Ruth Anspach, Herb and Nancy Baker, Richard Cohen, Allan Gerdau, Rita and John Grunwald, and Henry and Sarahanne Hope.

While the development of these collections has reflected the general pattern of the museum's growth, Roy Sieber has imparted a special instructional dimension. Throughout his nurturing of the collections he has sought not only masterpieces but also less than perfect examples as teaching tools. He has emphasized the meaning and the significance of the objects for the people who created and used them.

It is in recognition of Roy Sieber's efforts and of the generous support of our donors in creating this exceptional collection of the art of Africa, the Pacific, and the Pre-Columbian Americas that we dedicate this publication. The essays by Michael Coe, Douglas Newton, and Roy Sieber help illuminate the richness of the collection, which comes to life in the photographs of Michael Cavanagh and Kevin Montague. I would also like to thank Pat Darish, David Binkley, Linda Baden, and Brian Garvey for their dedication to preparing this work and the National Endowment for the Arts for its generous support, which has made this publication possible.

Thomas T. Solley
Director

Preface

For many years the Indiana University Art Museum's collections of African, Pacific, and Pre-Columbian art have been a "best-kept secret." In 1984, with plans underway for the permanent installation of the collections from these world areas in a recently dedicated building, it seemed time to bring them to a wider audience. Three renowned authorities were invited to contribute essays utilizing these objects as points of departure. Rather than lengthy discussions of individual pieces, we chose to establish a general framework for each geographic region and situate the examples within their respective cultural contexts. These essays, together with the published photographs, highlight the most important objects in the collection and mark the debut of a new era of research and scholarship at the museum.

In addition to extolling the merits of a strong university museum, this publication acknowledges the achievement of certain individuals including the director, Thomas T. Solley, and Professor Roy Sieber, who continue to be instrumental in the development of the collections. While other collections have been built with a great deal more fanfare, both of these individuals quietly and patiently built an exemplary collection that includes examples of outstanding pedigree and the highest aesthetic merit. The magnitude of their achievement will only become clearer as the collections begin to attract the attention they so warrant.

Working with Michael D. Coe, Douglas Newton, and Roy Sieber has been inspiring. In addition to their contributions, I would also like to thank David Binkley for his initial input and those members of the museum staff, especially Linda Baden, Brian Garvey, Michael Cavanagh, Kevin Montague, and Leslie Schwartz, whose dedication and commitment to excellence have made this publication possible.

Patricia Darish
Acting Curator

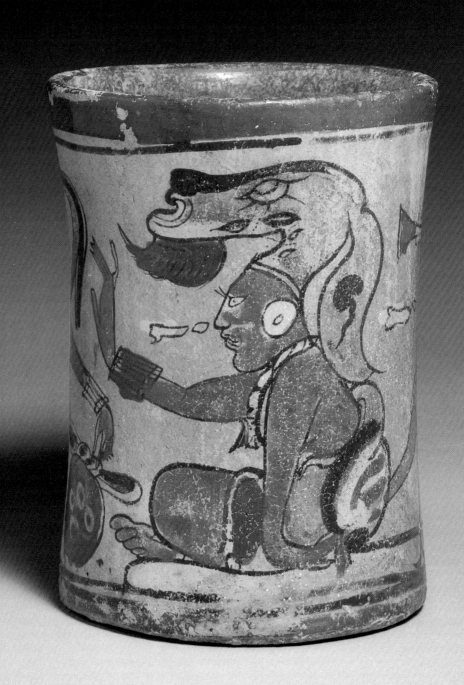

The Art of Pre-Columbian America

Michael D. Coe

Culture Areas

There is no more unity to the varied arts of pre-Columbian America than there is to the arts of Eurasia. Spread over thousands of miles of the most varied landscape and climate, and with a time depth of several thousand years, the high cultures of the Western Hemisphere exhibit a tremendous diversity. Nonetheless, within this cultural kaleidoscope, there are broad trends—what anthropologists call "culture areas"—which can be discerned.

Mesoamerica, meaning that part of Mexico and adjacent Central America that was civilized at the time of Spanish contact, is one of those areas. The most famous of its civilizations were the Aztec and Maya, although the far more ancient Olmec have an equal claim to our attention for the beauty of their sculptures and jade carvings.

Far to the south is the *Andean Area,* comprising the western part of South America; this was the seat of the great, but very late, Inca Empire, but settled life, art, and impressive architecture go back millennia before the Inca had appeared on the scene.

Between Mesoamerica and the Andean Area lies what anthropologists, for want of a better term, have called the *Intermediate Area*—Ecuador, Colombia, western Venezuela, Panama, Costa Rica, and Nicaragua. Although some of the world's finest gold objects have come from richly stocked tombs in this area, its artifacts are in general unappreciated outside of museum collections. Certainly nothing comparable to the great civilizations of Mesoamerica or the Andes ever existed here, although some chiefdoms, such as the Tairona and Chibcha of Colombia, approached what might be called a state level of organization.

Polychrome Vase
Maya, Late Classic period, ca. A.D. 700-800
Petén (?), Guatemala
Orange clay, slipped red, orange, black, gray, on buff
H. 15.6 cm
Raymond and Laura Wielgus Collection
80.114

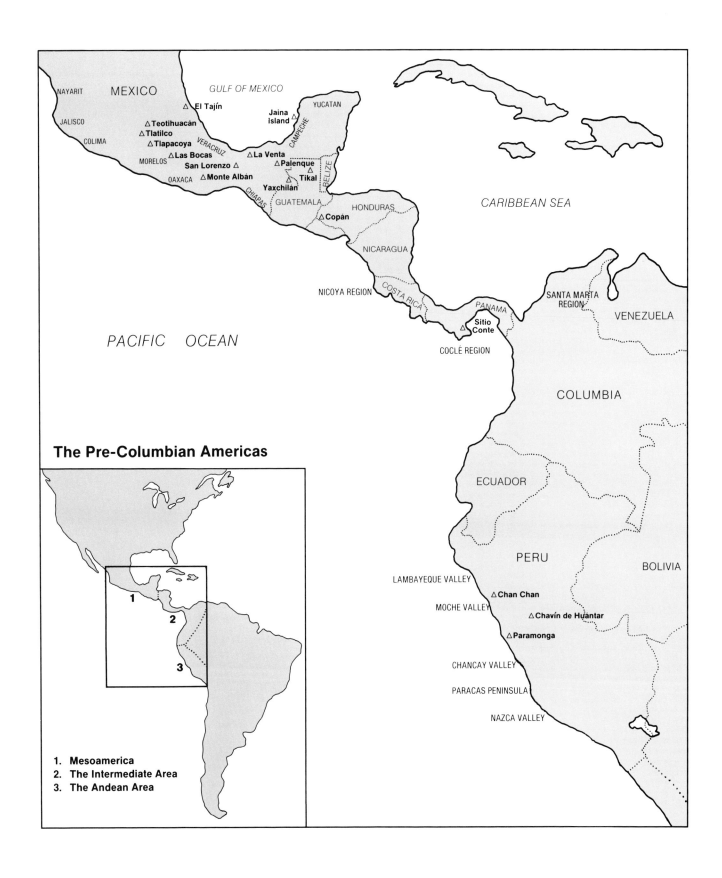

The Pre-Columbian Americas

1. **Mesoamerica**
2. **The Intermediate Area**
3. **The Andean Area**

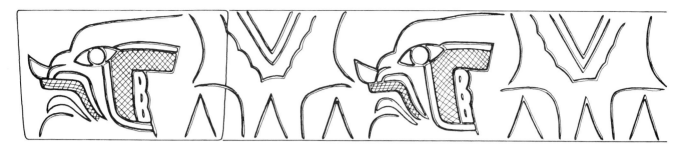

Fig. 1 Olmec bowl from Tlapacoya (no. 1)
Redrawn from *The Jaguar's Children*, Museum of Primitive Art, 1965, p. 28

Mesoamerica

Maize agriculture, on which Mesoamerican civilization depended, goes back seven thousand years in southern Mexico to a period in which there was no settled life, no real art, and only faint indications of a concern with the supernatural. It is not until after 2000 B.C. that farming became productive enough for villages, along with pottery and loom-woven textiles, to appear. This stage of early sedentism is called the Formative, and it lasts until the onset of the Classic stage, around the time of Christ. Until the discovery of the Olmec civilization in the 1930s and 1940s, the Formative stage was regarded as a time of only simple village farmers.

The complex nature of Olmec culture, which its discoverers claimed (we now know correctly) to be the "mother culture" of Mesoamerica, made most Maya specialists skeptical that the Olmec could have predated the earliest Classic Maya period. But all recent excavations have proven this civilization to be indeed Formative in date, beginning by at least 1200 B.C. and continuing until about 300 B.C. On the basis of current evidence, Olmec culture arose in a "heartland" area in the southern lowlands of Veracruz and Tabasco, a region of heavy precipitation where the rivers overflow their banks during the summer rainy season, finally retreating in the dry season to leave silt-rich floodplains; this Nile-like situation gave rise to the most productive corn farming in Mesoamerica and led to the appearance of its oldest civilization.

The best-known Olmec sites, such as San Lorenzo and La Venta, are famed for their gigantic basalt monuments, including the so-called "Colossal Heads," multi-ton sculptures that most specialists believe to be portraits of Olmec rulers. Present from the very beginning of Olmec civilization is a complex pantheon of gods, creatures combining the features of humans (often infants) with terrifying beasts from the tropical forest such as the jaguar, cayman, and harpy eagle. Typical of the unique Olmec art style are representations of supernaturals with snarling, down-drawn mouths and mongoloid features.

During the Early Formative stage, from 1200 to about 900 B.C., Olmec influence spread over much of what we now know as Mesoamerica. These Olmec voyagers were the great civilizers, whether traders, missionaries, or conquerors. Pottery with the distinctive style appears in elite graves at many highland Mexican sites, including Tlapacoya in the Valley of Mexico, from which a fine, whiteware bowl probably comes (fig. 1; no. 1); here we see an incised representation of a "were-jaguar" with striped eye, an enigmatic Olmec deity whose significance has yet to be discovered. Another important "extra-heartland" site is Las Bocas, in the state of Puebla, where graves were richly stocked with Olmec goods, most of which were probably manufactured in heartland sites such as San Lorenzo. The grotesquely obese individual seen in number 3 is made of white-slipped orange-ware and is one of a number of typically Olmec figurines from this highland site.

Among collectors and archaeologists, the most renowned Formative-period site in the central Mexican highlands is Tlatilco, now totally destroyed by brickyard operations and modern development; located on the western side of Mexico City, it once contained thousands of graves placed below the floors of ancient, Early Formative houses. Along with a small number of Olmec mortuary offerings (proving its contemporaneity with San Lorenzo), Tlatilco has produced many thousands of figurines and vessels in a local style found in both the Valley of Mexico and the state of Morelos. The small ceramic figurine (no. 2) is typical of these: a delicately modelled dancer in a costume suggestive of dried seed pods.

The Valley of Mexico went into cultural decline after 900 B.C. (perhaps following the destruction of San Lorenzo, which took place about this time), retrogressing to a peasant level of organization as Olmec influence receded. Only the round "pyramid" of Cuicuilco, built in the southern part of the valley around 200 B.C., is testimony to any kind of cultural complexity in the Late Formative period of the central Mexican highlands. But about the time of Christ, an extraordinary culture was

coalescing in the Valley of Teotihuacán, an extension of the Valley of Mexico. The city of Teotihuacán, the largest urban conglomeration the pre-Spanish New World was ever to see, flourished during the Early Classic period (from the time of Christ to about A.D. 600) and declined to the point of destruction about A.D. 700. During its golden age, this great craft center, with its population of one hundred to two hundred thousand souls, held mercantile and political sway over most of Mesoamerica, including even the Maya highlands and lowlands (fig. 2).

Teotihuacán art has a hard, abstract, and perhaps even cruel aspect, as befits the military nature of the civilization. Typical of the style is the granite mask (no. 4), showing stains from pyrite "irises" that once filled its eyes (along with shell "whites"); such masks may have been fixed to funerary bundles in elite burials. One of the finest known Teotihuacán art objects is to be seen in number 5, an aragonite seated figure, perhaps an ancestral image from a tomb.

Archaeologically, the least known area of Mesoamerica is western Mexico—the states of Jalisco, Nayarit, and Colima—from which come vast quantities of large ceramic figures that seem to be ancestral images, found in deep tombs reached by shafts from the surface (we

may never know, since none of these have been excavated by archaeologists). The dating of these figures is problematical, but it is generally believed that most of them are Late Formative, ca. 400 B.C. to the time of Christ. On stylistic grounds, the earliest are probably figures in the so-called "chinesco" style, of which the seated female (no. 6) is a good example, with her somewhat "oriental" eyes (hence the name for the style) and decorative nose and arm ornaments. The Jalisco warrior brandishing a spear (no. 7) may not actually be a warrior, but a shaman fighting the evil demons that cause disease and other calamities. A third ceramic effigy from the same time frame, perhaps also from Jalisco (no. 8), is more enigmatic, and again it may be some kind of ancestral representation.

If little is known about the Late Formative tomb styles of western Mexico, even less is known about later styles from this region. An unusual and almost unique fan handle (no. 9) may be a Post-Classic (A.D. 1200-1521) item from the state of Colima, apparently representing a bound and partly nude captive standing on the coil of a snake.

Veracruz is archaeologically the richest state in Mexico. Of its thousands of ruins, most of them concentrations of earthen temple substructures, some are Olmec but

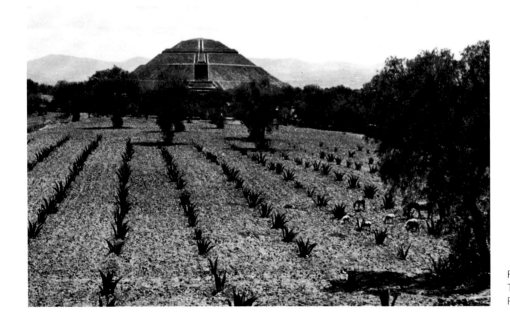

Fig. 2
The Temple of the Sun, Teotihuacán
Photo courtesy Michael D. Coe

the majority belong to the Classic period. Less is known about Classic than pre-Classic cultures, but particularly common in collections are large effigies of the wrinkled, androgynous Old Fire God. The Indiana University Art Museum has a fine example in number 10, a vase in the form of this important deity's head; the influence of the contemporary Early Classic culture of the Maya is evident here.

The stone sculptures of Classic-period central Veracruz, and at the great type site of El Tajín, center on the ceremonial ball game so important to Mesoamerican religion and cosmology. The game was played on special ball courts and with special equipment, and apparently it culminated with the sacrifice of the captain and possibly the entire team of the losing side, at least in Veracruz. During the post-game ceremonies, perhaps as a prelude to sacrifice, the victorious team paraded in stone "yokes" representing the protective belts they had worn in the contest, on top of which were affixed stone *palmas* (perhaps markers for the playing field). One such *palma* (no. 11) is in the form of a fantastic bird, possibly an Underworld bird of omen reflecting the death aspects of the ball game cult.

Veracruz is, of course, best known for its Olmec and Early Classic art styles, but the area remained an important region of settlement through the Classic and Post-Classic periods. The effigy vessel in the form of a monkey (no. 12) is a fitting portrait of a ferocious spider monkey holding its own tail, and it may well be an image of one of the twin monkey gods who were patrons of scribes, artists, musicians, and dancers in ancient Mesoamerica; it most likely is a product of Late Classic civilization, probably about A.D. 800-900.

The Valley of Oaxaca in southern Mexico was the seat of a powerful Zapotec state from the Middle Formative period onward, until increasing competition from rival Mixtec states in the Post-Classic period weakened its dominion over this part of Mesoamerica. The center of Zapotec political and cultural power was the hilltop site of Monte Albán, overlooking modern Oaxaca City. From this citadel, Zapotec rulers conquered town after town, chronicling their victories in the so-called "Danzante" reliefs of naked and mutilated captives taken during the Monte Albán I period. The remarkable gray-ware effigy head (no. 13), which might be interpreted as either the Old Fire God or the monkey-man patron of the arts, belongs to this Monte Albán I period; the probable date

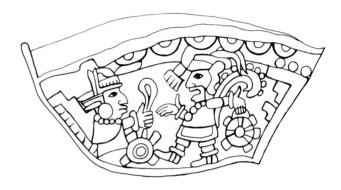

Fig. 3 Mixteca-Puebla-style shell (no. 14)

is about 300 B.C., almost in the Late Formative time span.

Following the demise of Classic Zapotec (Monte Albán III) civilization about A.D. 900, according to historical sources recorded after the Spanish Conquest, the Mixtec of northern Oaxaca began to infiltrate and perhaps conquer Zapotec towns. In some cases, the Mixtec and Zapotec seem to have coexisted in the same town. At this time the so-called Mixteca-Puebla art style, which was to be a powerful influence over much of Mesoamerica during the Post-Classic period, found expression in codices or folding-screen books of deer hide (most of which deal with royal genealogies), in polychrome pottery and wall paintings, and in very fine goldwork. The Indiana University Art Museum's tiny marine shell with a polychrome scene (fig. 3; no. 14) is a unique object in the Mixteca-Puebla style: it is embellished with two individuals who may be mythological ancestors, the right-hand personage bearing the star-studded curved snout of the Fire Serpent on his back.

Mixtec artistry in gold is among the New World's best, and it was probably Mixtec goldwork that was so admired by Albrecht Dürer, himself a goldsmith. The golden labret (no. 15) was, as is usual, cast by the *cire perdue* process and was worn below the lower lip of a high Mixtec official.

The Mixtec also controlled the Pacific coast plain of Oaxaca, and it is supposedly from this area that a group of skulls encrusted with turquoise and jet mosaic have come. Some of these have been heavily restored to the point that their authenticity has rightly been questioned, but the art museum's skull (no. 16), which was probably a trophy from a slain captive, is in pristine condition. It is closely comparable to the Mixtec mosaic skull from Tomb 7 at Monte Albán, while the shell appliqué of the eyes recalls the skull offerings of the Templo Mayor in Tenochtitlán, the Aztec capital.

There is no question that the Classic Maya civilization was the most complex and advanced of any in native America. It flourished from the end of the third century A.D. until its mysterious decline in the ninth century in the jungle-covered lowlands of northern Guatemala, Belize, Honduras, southeastern Mexico, and the Yucatán Peninsula. The Maya had the most complete writing system of the pre-Spanish New World, and recent epigraphic breakthroughs have enabled us to read much of the dynastic records that they inscribed on stone in great lowland cities like Tikal, Palenque, Yaxchilán, and Copán.

The Maya art style is highly realistic and is unique in the Mesoamerican tradition for its concern with portraiture of individual rulers. Most striking are the tiny portrait figurines in fired clay from the island of Jaina, off the Campeche coast, of which the object in number 17, a Late Classic personage with folded arms, is an excellent example. All of these figurines have come from graves on the island, and perhaps many represent the defunct.

The art museum has an exceptionally fine group of Late Classic Maya vases painted or carved with elaborate scenes; these were produced in the eighth century A.D., either in the northern lowlands of Guatemala or in southern Campeche. For many years, the artists who embellished these vases and dishes were considered by specialists to be little more than semi-illiterate peasants with virtually no knowledge of either the writing system or the esoteric religion of the Maya elite. However, my own research has demonstrated that these funerary ceramics, which are found only in elite graves and tombs, deal with a rich, complex iconography that often refers to the Underworld, and that the hieroglyphic texts are meaningful.

The fine polychrome vase (fig. 4; color plate, p. 8) is a case in point, with four personages in a palace scene. The central figure, seated on a kind of throne, wearing a fantastic deer headdress, may well be the defunct lord for whom the vase was painted, for to his right is an aged deity, known to archaeologists as God N, who is one of the principal rulers in Xibalbá, the Maya Underworld. From the "realism" of this scene, we turn to another polychrome vase (no. 19), with the head of an unknown Maya deity repeated twice; just below the rim is a horizontal band of elegantly painted hieroglyphs. Analysis of hundreds of similar texts has enabled me to establish this as the Primary Standard Sequence (PSS), a fixed formula of glyphs that may represent some kind of funerary chant.

Even more abstract is another fine polychrome cylinder (no. 18) on which can be discerned god heads and water vegetation in an extraordinarily complex pattern typical of the Maya horror vacui. There were seemingly hundreds of distinct supernaturals in the Maya Underworld, the destination of all after death, but we are only in the early stages of working out this bewildering iconography.

The outstanding Classic Maya piece in the Indiana University Art Museum's holdings is a magnificent vase (fig. 5; no. 20) with a wonderfully elaborate series of interconnected scenes. To the left is an Underworld palace, in the second story of which an infernal ruler is enthroned beneath a swagged curtain; this is the jawless God of the month Pax, associated with ritual bloodletting, who gestures toward the aged God D, the supreme ruler of the upper world. Above God D is the sinister Moan Bird, the messenger of the Underworld lords. In back of God D are two unidentifiable supernaturals playing drums, one shaking a rattle. Another orchestra plays in the palace's lower story, while a weird deity squats before a stew-pot.

The right-hand field in the rollout has two sets of twins. Standing on the left are what must be the Hero Twins, Hunahpu and Xbalanque, who in the great Maya epic, the Popol Vuh, defeat the dread infernal gods and become the sun and moon. They seem to have smoking tubes in their hands. Above them flitters a bat, probably a reference to the House of Bats, one of the terrible houses of torture into which the twins were placed

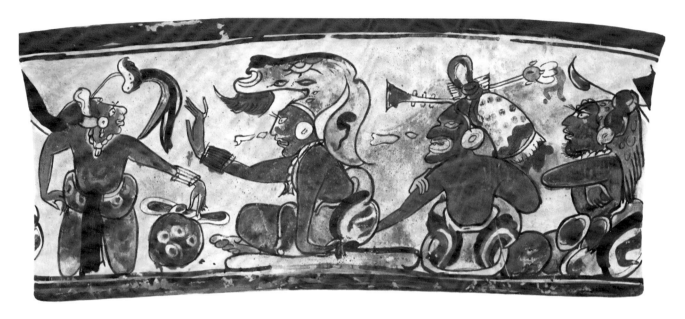

Fig. 4 Maya vase (color plate, p. 8). Watercolor by Claude Bentley

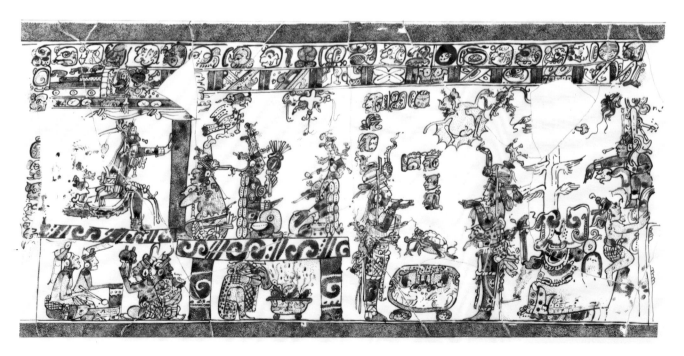

Fig. 5 Maya vase (no. 20). Drawing by Diane Griffiths Peck

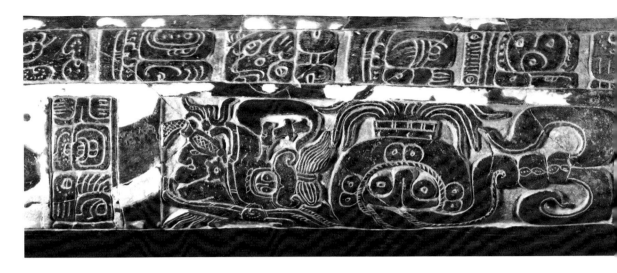

Fig. 6 Maya carved bowl (no. 23)
Rollout photo by Justin Kerr

before their eventual triumph. To the right of the twins is the gigantic head of the Cauac Monster; above it grows a strange tree on which a fantastic bird, now obliterated, once perched. A further pair of twins with headbands climb another tree on the far right; I believe these to be the Hero Twins again, shown in a different time frame.

Pictorial Maya ceramics were also carved, particularly in the Yucatán Peninsula, whence come three such vessels in the museum's collection. The first is a tripod cylinder (no. 22) with a carved panel of a deity head with large "god-eye" and upturned snout; this seems to be a version of God K or Bolon Dzacab, recognizable from the tube set in the forehead. God K was the patron of royal descent and lineage and often appears on Classic Maya stelae and other monuments as a kind of effigy scepter held by great rulers.

Another cylindrical vase (no. 21) from Yucatán or northern Campeche is carved from the pottery known as slateware and shows a handsome young man with markings on his arm, back, and thigh that announce his status as a divinity. He may well be the young Maize God, father of the Hero Twins, who was decapitated in the Underworld according to the Popol Vuh myth.

That the Maya artists could masterfully carve quite elaborate scenes on shapes far more complicated than cylinders is demonstrated by a composite bowl from Yucatán (fig. 6; no. 23) that has been partly stuccoed after firing. On either side of the bowl, below a glyph band that cannot yet be read satisfactorily, is a panel

with the fantastic creature I have named the Bearded Dragon. One of these serpents has the symbol for the planet Venus in the coil of its body and in its eye; from its jaws emerges the old God N, whom we have previously seen. The other dragon is very similar, but without the Venus glyphs.

Large, hollow pottery tubes with side flanges have been found in Late Classic contexts at the great site of Palenque, in Chiapas (fig. 7), but they are especially common in nearby caves and caverns. They are generally believed to be incense burners and almost certainly have Underworld associations, since to the ancient (and modern) Maya, caves are entrances to the infernal regions. The fine example in the Indiana University Art Museum (no. 24) bears a set of stacked supernatural heads on the tube, the middle and most prominent one being a terrifying bat with snarling mouth, surely the Cama Zotz or Killer Bat that almost did away with the Hero Twins in the Popol Vuh.

To the Classic Maya, as to all other peoples in Mesoamerica from the Olmec on, jade was the most precious substance; it was worn by members of the elite and ended up in their graves as offerings to them. The remarkably fine jade pendant (no. 26) in the art museum is a wonderful apple-green color and probably was carved in the Petén, Guatemala. The head is of a supernatural with large "god-eyes" and prominent front teeth, most likely the Sun God. Jade is an extremely hard stone, and it should be remembered that this, like all Maya jades, was worked without benefit of metal tools.

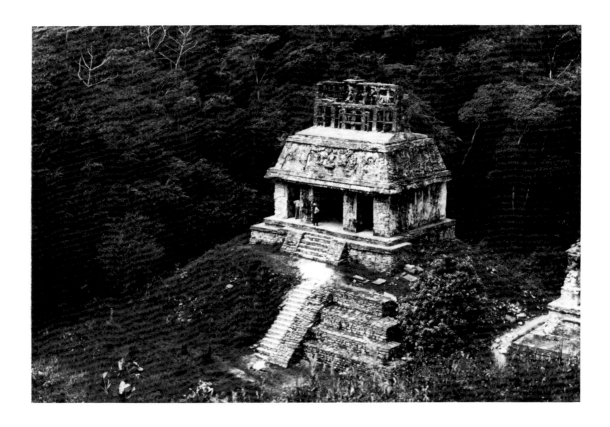

Fig. 7 The Temple of the Sun at Palenque
Photo courtesy Michael D. Coe

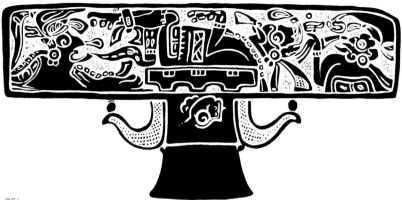

Fig. 8 Maya ornament (no. 25)

Marine shell was another highly prized substance often found in Classic tombs. The Late Classic shell plaque (fig. 8; no. 25) is without provenance, but it could have come from Jaina in Campeche, where the calcareous soil has preserved substances, such as shell and bone, which elsewhere would have disintegrated in the tropical environment. The important scene carved and incised on it, like those on pictorial vases, is clearly set in the Underworld. Reclining on a kind of platform in the center is the Jaguar God of the Underworld, a Roman-nosed divinity representing the Night Sun as it moves into Xibalbá at the end of each day. He may be about to be sacrificed by the two flanking figures: on the left God L, co-ruler in the land of the dead with God N; on the right, the God of Pax.

The introduction of metallurgy into Mesoamerica probably took place from northern Peru and/or southern Ecuador about 850 A.D. Isolated objects cast from gold may have found their way into the Maya lowlands in earlier centuries, but surely most of Mesoamerica was in the "Stone Age" before the end of the ninth century. There are, however, certain enigmatic copper objects cast by the *cire perdue* or "lost wax" process that seem to come from the Maya area, which *might* have been manufactured prior to 900 A.D. One of these is an unusual, large copper bell (no. 27), cast in the form of a goggly-eyed, flat-nosed, thick-lipped personage. This example is said to have originated in Honduras, but a very similar specimen is supposed to be from the famous Totonac site of El Tajín, in north-central Veracruz. As of now, both the dates of these objects and their places of origin remain uncertain.

The Intermediate Area

The archaeology of the Intermediate Area is still in its infancy, since the more spectacular native cultures to the north and south have for more than a century claimed the attention of most researchers. Yet, thanks to field excavations carried out in the past twenty-five years, we now know something about what happened in Costa Rica, and, by extension, in neighboring Nicaragua. The region known as Greater Nicoya, comprising the Nicoya and Rivas peninsulas of both countries, has been the source for many of the most spectacular small-scale stone carvings and jades from this general area. According to current chronologies, the stone mace-head in the art museum (no. 28) belongs to the Early Polychrome period of Greater Nicoya, ca. A.D. 500, and must come from one of the ubiquitous cemeteries of the region, where it would have been associated with elaborately carved metates and some of the jade "axe-gods" for which Nicoya is noted.

It is usually very difficult to date Costa Rican carvings, since few have come from controlled excavations. The wonderful little chalcedony figurine (no. 29) could be an Early Polychrome piece from Nicoya, or it might be later and from the Costa Rican highlands or the Atlantic slope.

With a few exceptions, most of Panama is equally unknown to modern archaeology. One of the exceptions is the Coclé region of central Pacific Panama, particularly the famous Sitio Conte, where excavations by the University of Pennsylvania and Harvard University disclosed a fantastically rich cemetery of chieftains' graves with abundant polychrome pottery, agate, gold, and ivory artifacts, all believed to date from about A.D. 500 to 1000. Accompanying the most lavish of these burials were human skeletons in profusion, apparently the result of the sacrifice of retainers, perhaps including wives. The crocodile god carved from manatee bone (no. 31) is typical of the Coclé style, although it is not quite so fine as some examples that have been embellished with gold.

Probably the most complex of the ancient cultures of the Intermediate Area, far superior to the Chibcha civilization of the Colombian highlands so touted by the Spanish conquistadores, was the Tairona civilization of the Santa Marta area of northeastern Colombia. The very finest of New World gold and tumbaga (gold and

copper alloy) objects come from this region and date to the final centuries before the conquest. They reflect the advanced nature of Tairona culture, with its teeming towns, stone-paved roads, and temples. The fine, lost-wax casting of the art museum's labret (no. 30) recalls the productions of the Mixtecs of southern Mexico, but its alligator iconography and the far greater time depth of metal-working in Colombia show that there can be no connection between the two cultures.

The Andean Area

The Andean Area encompasses strikingly disparate environments. From the lofty Andean peaks of the *cordillera* to the Pacific coast is a vertical distance that sometimes surpasses 19,000 feet. But two great cultural-ecological zones can be distinguished. One consists of the broad, cool, grass-covered intermontane valleys and lake basins of the highlands, where maize is often grown but remains marginal to such highland crops as potatoes and quinoa, and where the domestic camelids—llamas and alpacas—are important for food and transport. The other is the Pacific coastal area of short, precipitous valleys with intensive irrigation of crops such as corn, beans, and squashes, abruptly surrounded by bone-dry deserts.

The very diversity of the Andean Area would naturally lead to local specialization and diversification; yet at several times during its culture history, major unifying movements (or "horizons," as archaeologists call them) have occurred. The earliest of these is called Chavín, after the type site of Chavín de Huántar in the Peruvian highlands. This seems to have been a major religious movement, approximately coeval with the Olmec civilization of Mexico, with a very similar pantheon of supernaturals centering on the worship of fearsome tropical forest animals such as the jaguar, harpy eagle, and cayman. The question of whether these two earliest New World high cultures were directly connected is still a topic of debate; I believe that they were.

Latest archaeological evidence indicates that the earliest Chavín manifestations are not in the highlands of Peru, but in the valleys of the north coast, where the subculture, known mainly from burial sites, is called Cupisnique. The dating of these graves may be slightly after 900 B.C. Cupisnique ceramics feature vessels with so-called stirrup spouts, establishing a north coastal tradition that was to last even into the Colonial period. The Chavín-horizon spouts, however, are massive, and

the Cupisnique jars are largely decorated by plastic means, rather than painted as in later cultures. Such is the case of the impressive stirrup-spout jar (no. 33) in which a rustic, combed decoration is carried out to contrast with smoothed areas on the upper part of the spout and under the "stirrup."

Stirrup spouts are rare on the south coast of Peru, the tradition there running to polychroming of round-bottomed bowls and jars topped with double spouts joined by bridges. In the area of Nazca and the Paracas Peninsula, there is a long sequence of evolutionary changes in ceramics found in graves, from quite Chavín-like vessels to ones that more closely approach the well-known jars and bowls of the Nazca civilization. A fairly early Paracas bowl in this tradition is seen in number 32, on which a highly stylized fox figure has been deeply incised, with later polychroming in resin-based pigments; it may date to a century or so before our era.

The formalized, somewhat abstract, but highly colorful south coastal tradition continues into the poorly known Nazca civilization, perhaps most famed for the huge desert figures—geometric and zoomorphic—which are best seen from the air. A double-spout-and-bridge polychrome jar (no. 34) is an excellent example of the lively Nazca mode of painted vessels, with a whiskered cat demon delineated in a very appealing manner (even though the ultimate meaning of this form, unknown to us, may have been far more sinister than the image leads us to believe).

The Andean Area's most distinctive civilization—and the one most sympathetic to foreign eyes—is the Moche culture, centered in the valleys of the north coast. Its most impressive remains are the gigantic Huaca del Sol and Huaca de la Luna, enormous platform-pyramids of unbaked adobes comparable in size to some of the Mexican and Egyptian pyramids. This culture, which probably dates from about A.D. 400 to 800, is famed for its highly realistic ceramics, which include stirrup-spout jars in white and red depicting not only many aspects of daily life—hunting, fishing, weaving, and the like—but also the physiognomies of the rulers of these coastal valleys. In pre-Spanish times, only the contemporary Maya of Mesoamerica had such an interest in individual portraiture.

The Moche rulers had access to large deposits of copper as well as gold, and the technology of metallurgy

was an old tradition here. A finial in the form of a fox head (no. 36) was perhaps attached to the end of a litter pole; it is a fine example of Moche metalwork, with lolling tongue, spangles on the ears and chin, and shell-inlaid eyes. Because of occasional rains on the north coast of Peru (particularly during the infrequent but disastrous El Niño incursions), wood, textiles, and other perishable materials are rarely preserved for the Moche civilization. Thus, a large ceremonial digging stick in Moche style (no. 35) is an almost unique item for this part of the Andean Area. Its ferocious subject matter has been presented before in Moche ceramics: a jaguar attacks a human victim, who is stretched out in agony. This emotional group was once embellished with shell and copper inlay, set in a resin base, and it well exemplifies the strong realism of Moche iconography.

A polished gray double-jar (which whistles when filled with water and tilted) reflects a style that is far more austere than the pictorial painted jars of Moche (no. 37). The subject is a dog or fox. According to experts, it is from the north coast of Peru and dates to the A.D. 800-1200 period.

Because of their extraordinary dryness, at least south of the Moche area, the coastal valleys of Peru have produced the greatest collection of ancient textiles in the world, hailing from every period from Chavín through Inca. Among these are examples in the Indiana University Art Museum's collection, the finest piece (no. 38) being a gauze-like, openwork cotton fabric from the Chancay Valley with lively figures related to the Chimú art style of north coastal Peru, which flourished from about 1000 A.D. until the destruction of the Chimú capital, Chan Chan, after the mid-fifteenth century A.D. (fig. 9). Also of probable Chimú or perhaps Chimú-influenced manufacture is a fine wooden comb topped with a standing figure (no. 40), bearing above the teeth of the comb the interlocked-snake motif so typical of Chimú culture.

Finally, the charming little shell-inlaid copper finial of a bird (no. 39)—possibly a hummingbird—could be either Moche or Chimú, and it exhibits the artistry, both realistic and even humorous, of these ancient Andean craftsmen, so remote in both space and time.

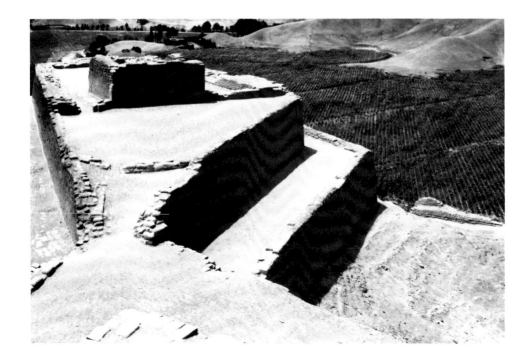

Fig. 9
View from Paramonga, a Chimú fortress, north coast of Peru
Photo courtesy Michael D. Coe

Suggestions for Further Reading

On Mesoamerica:

Coe, Michael D. *Mexico.* Revised and enlarged edition. London and New York, 1984.
_____. *The Maya.* Third edition. London and New York, 1984.
Weaver, Muriel Porter. *The Aztecs, Maya, and Their Predecessors.* Second edition. New York, 1981.

On the Intermediate and Andean Areas:

Baudez, Claude F. *Central America.* Archaeologica Mundi. Geneva, Paris, and Munich, 1970.
Lanning, Edward P. *Peru before the Incas.* Englewood Cliffs, N.J., 1967.
Willey, Gordon R. *An Introduction to American Archaeology; Volume Two, South America.* Englewood Cliffs, N.J., 1971.

1
Incised Bowl
Olmec, Early Formative period, 1200-900 B.C.
Tlapacoya, Valley of Mexico
Gray clay, cream slip, black pigment
H. 11.2 cm
Raymond and Laura Wielgus Collection
81.32.3
Former collection of George Pepper

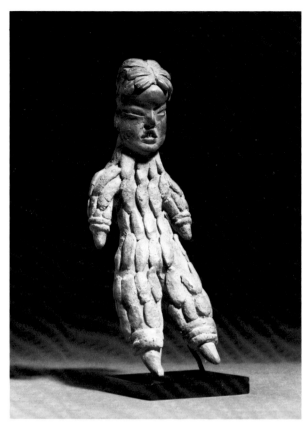

2
Figurine of a Dancer
Tlatilco, Early Formative period, 1200-900 B.C.
Valley of Mexico
Tan clay, traces of red pigment
H. 12.9 cm
Evan F. Lilly Memorial
70.57

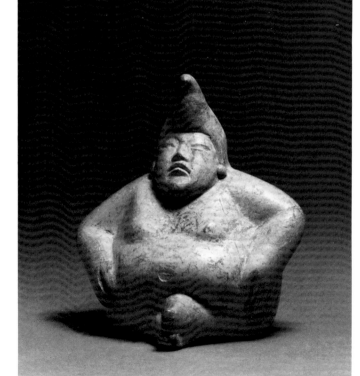

3
Seated Figurine
Olmec, Early Formative period, 1200-900 B.C.
Las Bocas, Puebla, Mexico
Orange clay, white slip, traces of cinnabar
H. 11 cm
Raymond and Laura Wielgus Collection
100.18.5.79
Former collection of George Pepper

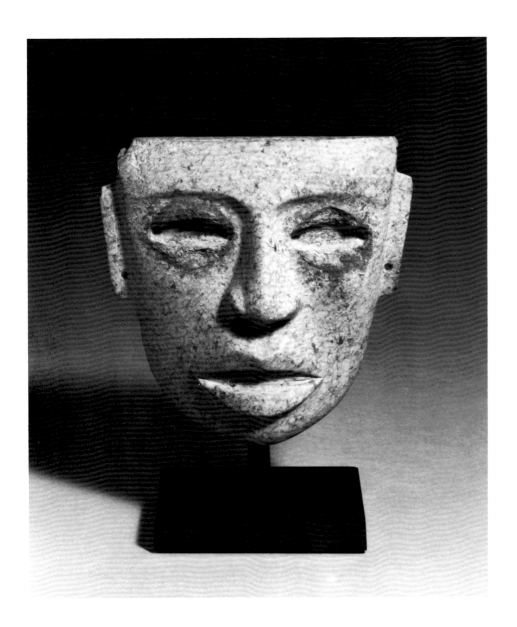

4
Mask
Teotihuacán III, Classic period, ca. A.D. 500
Puebla, Mexico
Metamorphic granite (gneiss)
H. 16.3 cm
79.6.2

5
Seated Figure
Teotihuacán III, Classic period, ca. A.D. 500
Valley of Mexico
Aragonite
H. 25.4 cm
Raymond and Laura Wielgus Collection
76.8
Former collection of Miguel Covarrubias

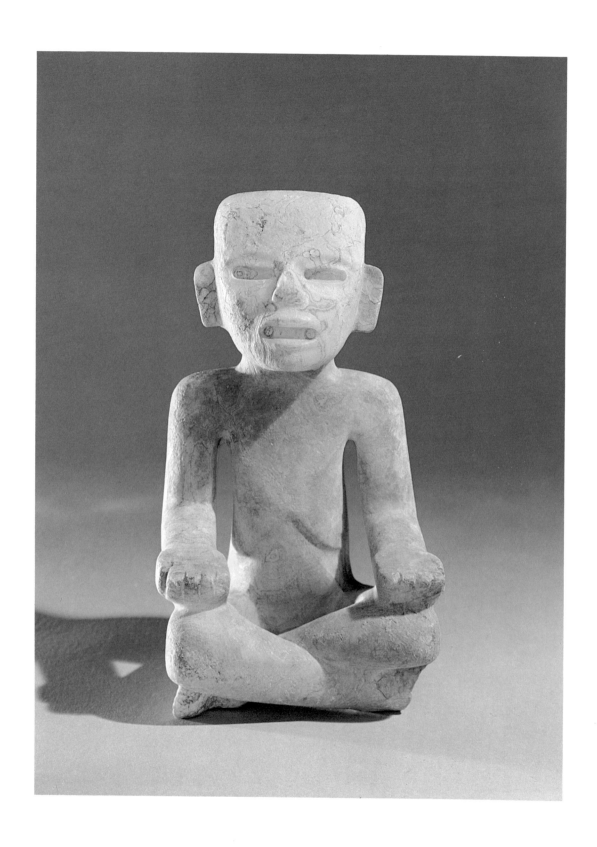

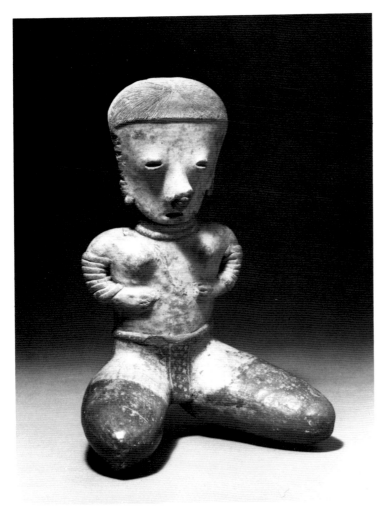

6
Female Figure
Nayarit (Chinesco style), ca. 200 B.C.
Nayarit, Mexico
Orange clay; buff and red pigment
H. 41.7 cm
Evan F. Lilly Memorial
69.102.3

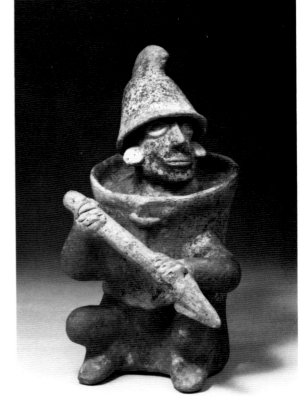

7
Warrior or Fighting Shaman Figure
Jalisco, ca. 100 B.C.
Jalisco, Mexico
Buff clay; red, black, and white pigment
H. 29.7 cm
Gift of Dr. and Mrs. Henry R. Hope
65.67

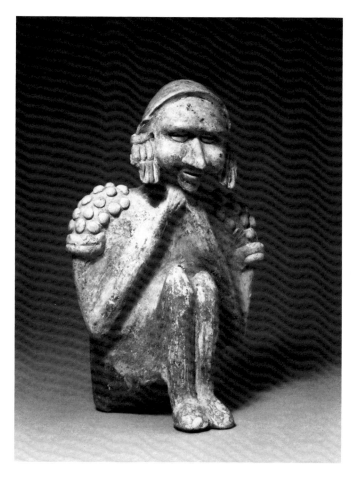

8
Seated Figure
Jalisco (?), ca. 100 B.C.
Jalisco, Mexico
Buff clay, red pigment
H. 22.6 cm
72.42.3

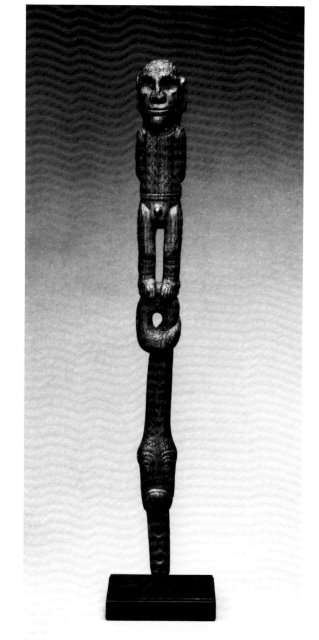

9
Fan Handle
Colima, Post-Classic period, A.D. 1200-1521
San Jerónimo, Colima, Mexico
Wood
H. 31 cm
Raymond and Laura Wielgus Collection
100.16.5.79

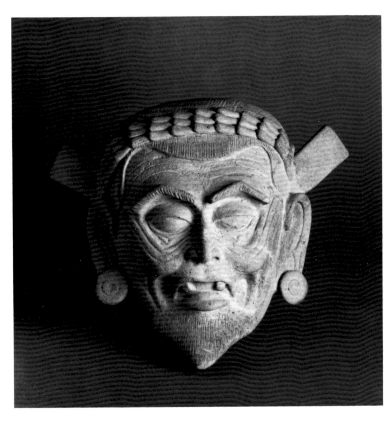

10
Vase in the Form of a Head of the Old Fire God
Veracruz, Early Classic period, ca. A.D. 500-600
Cerro de Las Mesas, Veracruz, Mexico
Orange clay
H. 23.5 cm
Raymond and Laura Wielgus Collection
77.93

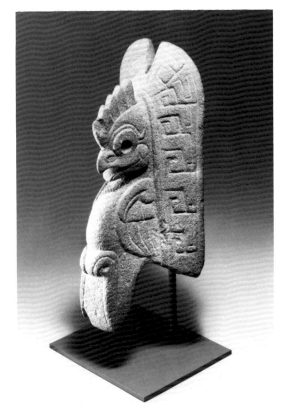

11
Palma
Veracruz, Classic Central style, ca. A.D. 600-700
Veracruz, Mexico
Stone
H. 38.2 cm
62.18

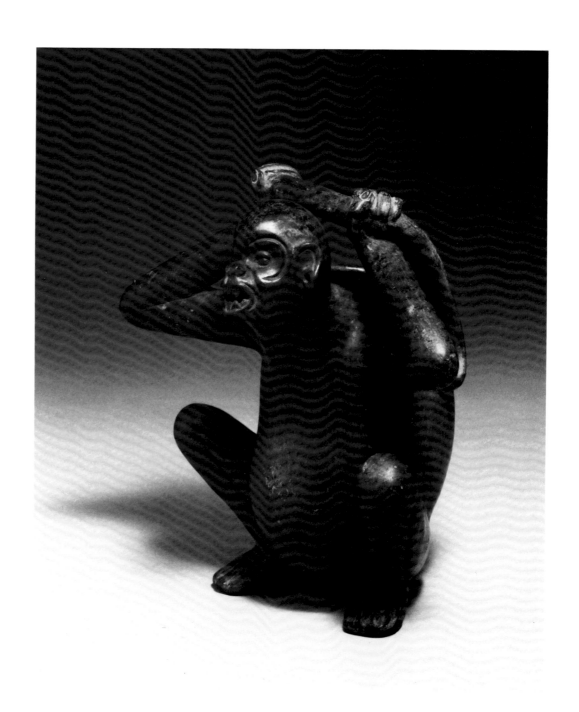

12
Effigy Vessel in the Form of a Monkey
Veracruz, Late Classic period, ca. A.D. 800-900 (?)
Veracruz, Mexico
Burnished gray brown clay
H. 22 cm
Raymond and Laura Wielgus Collection
100.7.4.75

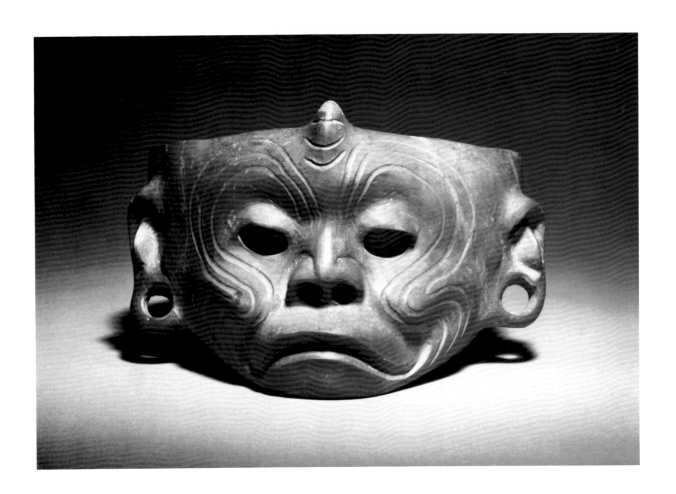

13
Effigy Bowl in the Form of a Head
Zapotec, Monte Albán I, 600-200 B.C.
Oaxaca, Mexico
Burnished gray clay
H. 11.8 cm
Raymond and Laura Wielgus Collection
81.32.4

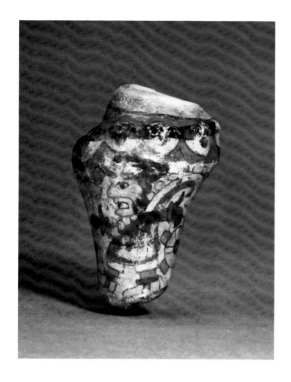

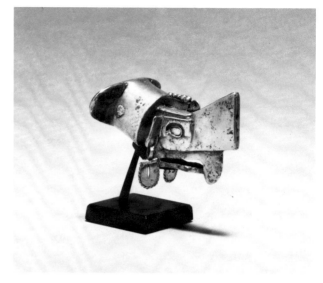

14
Polychrome Shell
Mixteca-Puebla style, Late Post-Classic period,
A.D. 1200-1521
Oaxaca, Mexico
Marine shell, green, blue, red, black pigment
H. 6.3 cm
80.65

15
Labret
Mixtec, Late Post-Classic period,
A.D. 1200-1521
Oaxaca, Mexico
Cast gold
H. 3.5 cm
Raymond and Laura Wielgus Collection
78.11.1

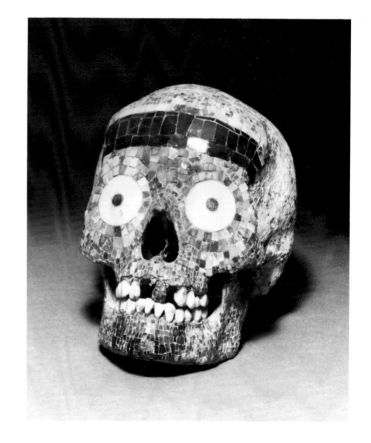

16
Decorated Skull
Mixtec, Late Post-Classic period,
A.D. 1200-1521
Oaxaca, Mexico
Human bone, turquoise, jet, shell
H. 15.5 cm
64.15

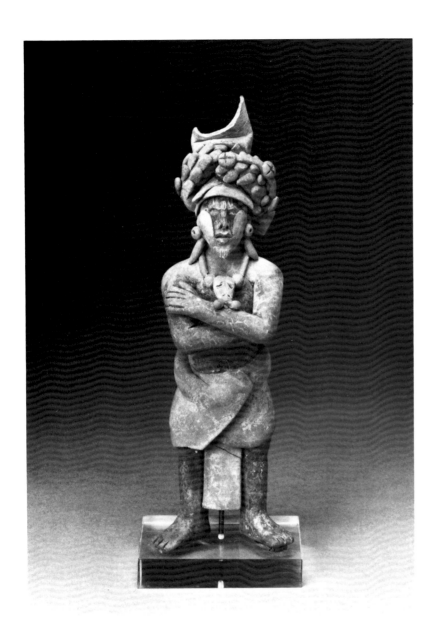

17
Figurine
Maya, Late Classic period, ca. A.D. 700-800
Jaina, Campeche, Mexico
Clay, traces of blue pigment
H. 19.6 cm
Evan F. Lilly Memorial
72.48

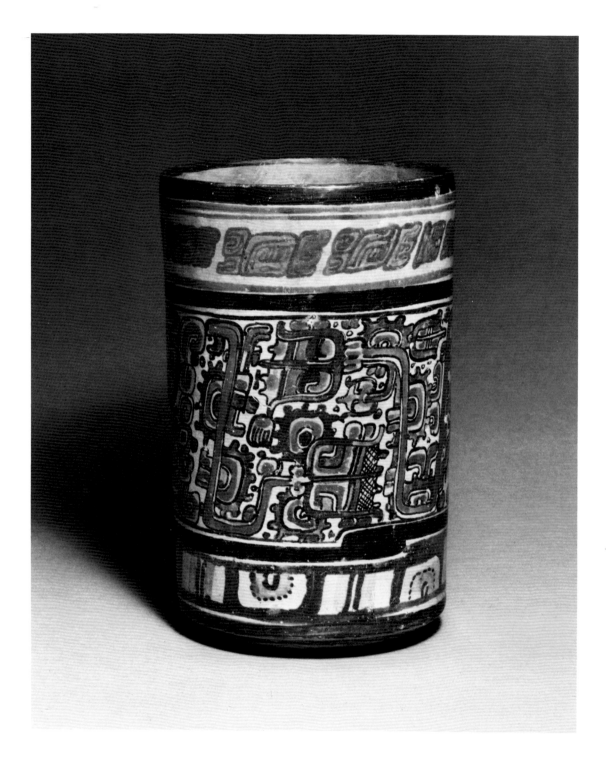

18
Polychrome Vase
Maya, Late Classic period, ca. A.D. 700-800
Petén (?), Guatemala
Orange clay; slipped black, gray, orange, red, on buff
H. 22.5 cm
Gift of Gordon Saks
80.110.1

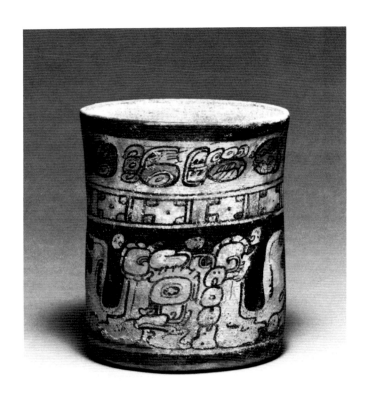

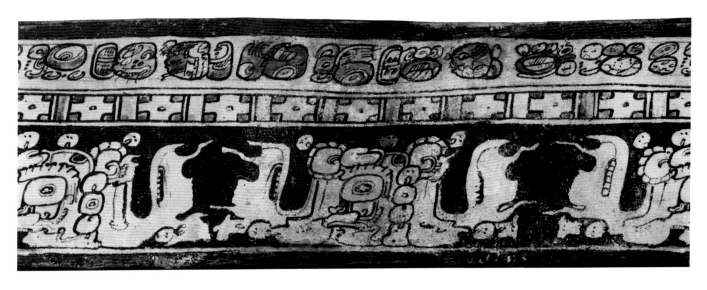

19
Polychrome Vase
Maya, Late Classic period, ca. A.D. 700-800
Petén (?), Guatemala
Orange clay; slipped black, red, gray, on buff
H. 13.1 cm
Gift of Gordon Saks
80.110.2
(Rollout photo by Justin Kerr)

▶ 20
Polychrome Vase
Maya, Late Classic period, ca. A.D. 700-800
Petén (?), Guatemala
Orange clay; slipped red, orange, black, gray, on buff
H. 24.7 cm
73.10.1

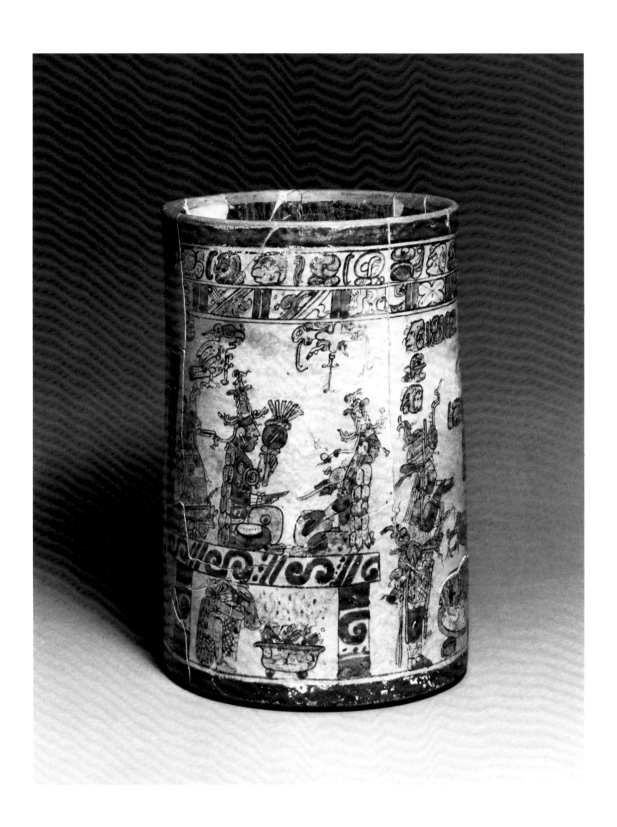

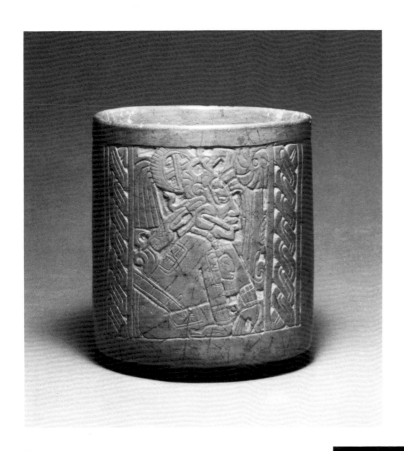

21
Carved Vase
Maya, Late Classic period, ca. A.D. 700-800
Yucatán or northern Campeche, Mexico
Burnished yellow clay (slateware)
H. 14.1 cm
73.10.2

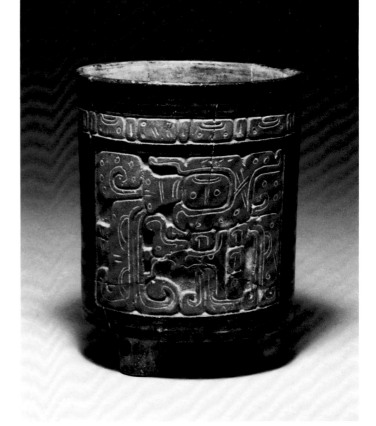

22
Carved Tripod Vase
Maya, Late Classic period, ca. A.D. 700-800
Yucatán, Mexico
Gray clay, black slip (blackware)
H. 18 cm
70.53

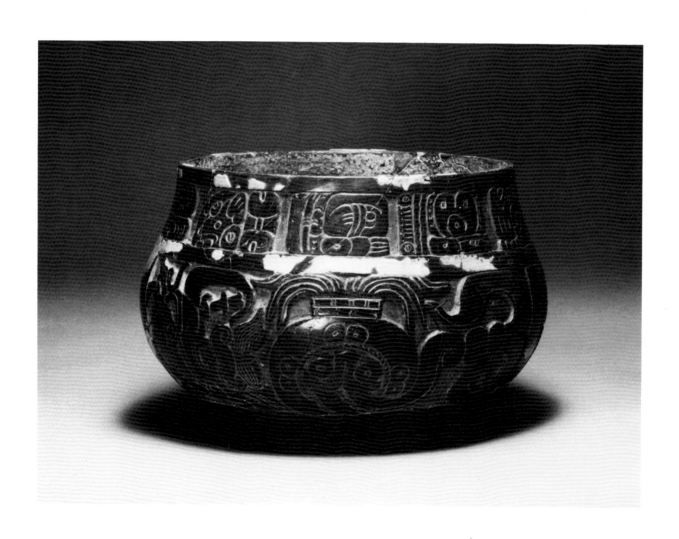

23
Carved Bowl
Maya (Chocholá style), Late Classic period, ca. A.D. 700-800
Yucatán or Campeche, Mexico
Red clay, black slip, greenish white stucco
H. 11.7 cm
73.10.3

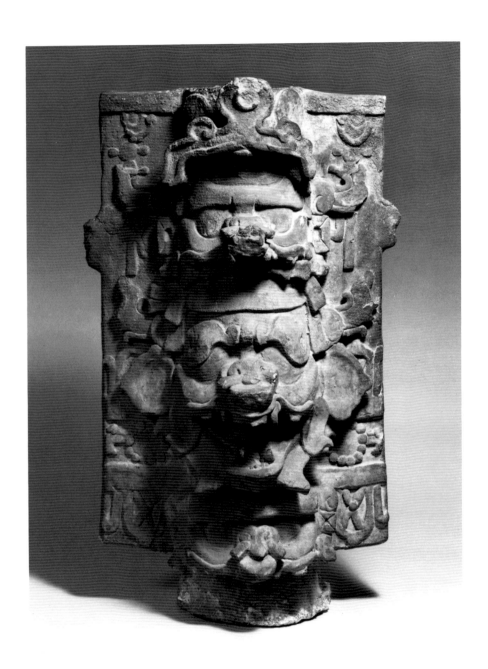

24
Incense Burner
Maya, Late Classic period, ca. A.D. 700-800
Chiapas, Mexico
Clay
H. 62.2 cm
65.19

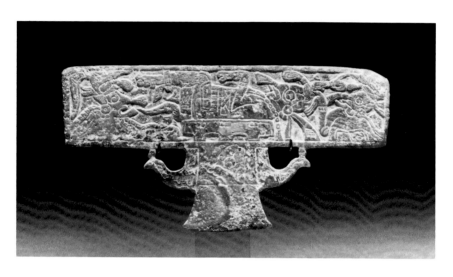

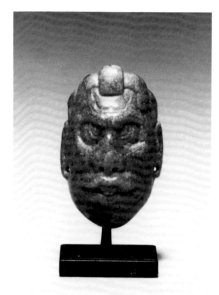

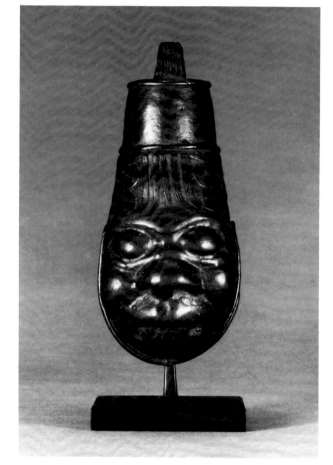

25
Carved and Incised Shell Plaque
Maya, Late Classic period, ca. A.D. 700-800
Jaina (?), Campeche, Mexico
Shell
H. 5.7 cm
Raymond and Laura Wielgus Collection
81.32.1

26
Pendant in the Form of the Sun God
Maya, Late Classic period, A.D. 600-900
Petén (?), Guatemala
Jadeite
H. 4.4 cm
Raymond and Laura Wielgus Collection
77.91

27
Bell
Maya (?), before A.D. 900 (?)
Quemislan, Santa Barbara, Honduras (?)
Cast copper
H. 12 cm
Raymond and Laura Wielgus Collection
81.32.2

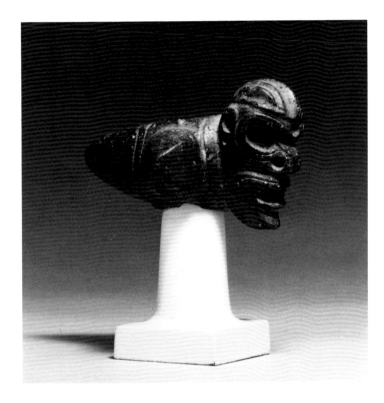

28
Mace Head with Human Face
Greater Nicoya, Early Polychrome period, ca. A.D. 500
Guanacaste Province, Costa Rica
Yellow igneous stone
L. 12.1 cm
Raymond and Laura Wielgus Collection
62.102

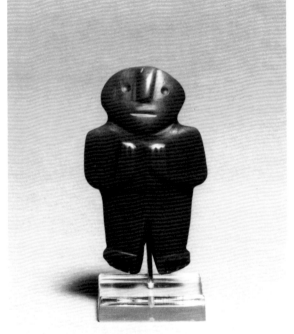

29
Pendant
Costa Rica
Chalcedony
H. 5.1 cm
Raymond and Laura Wielgus Collection
80.102

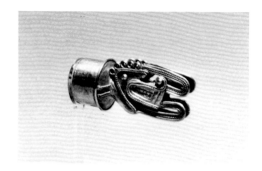

30
Labret in the Form of a Stylized Alligator Head
Tairona, A.D. 1000-1500
Santa Marta, Colombia
Cast gold
L. 4.3 cm
72.18

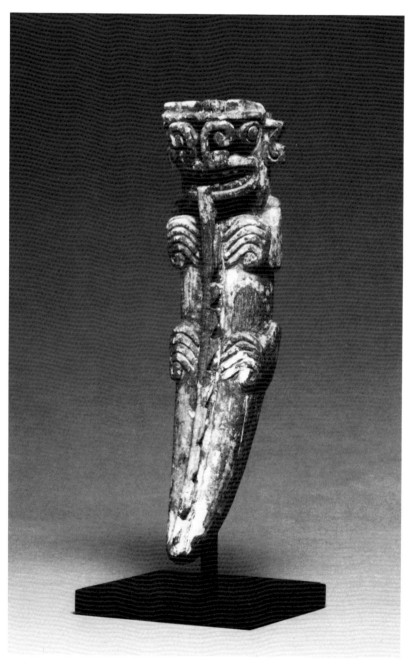

31
Crocodile-God Pendant
Coclé, A.D. 500-1000
Coclé, Panama
Manatee bone
H. 16.1 cm
Raymond and Laura Wielgus Collection
79.6.1
*Collected by Samuel K. Lothrop, grave 24, Sitio Conte, Coclé;
former collection of Peabody Museum, Harvard University*

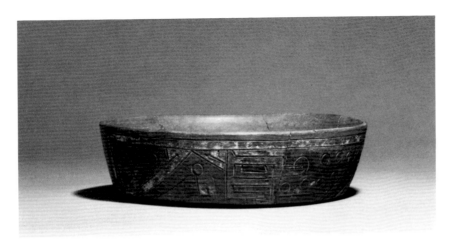

32
Incised Bowl
Early Paracas, ca. 100 B.C.
South coast, Peru
Orange clay, red and black pigment
H. 4.3 cm
66.16

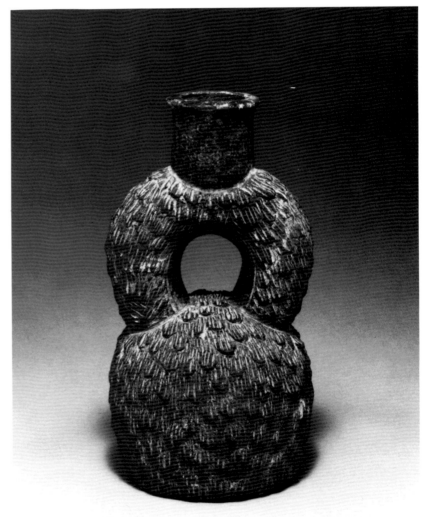

33
Stirrup Spout Jar
Chavín (Cupisnique style), 900-800 B.C.
North coast, Peru
Gray clay
H. 22 cm
72.101

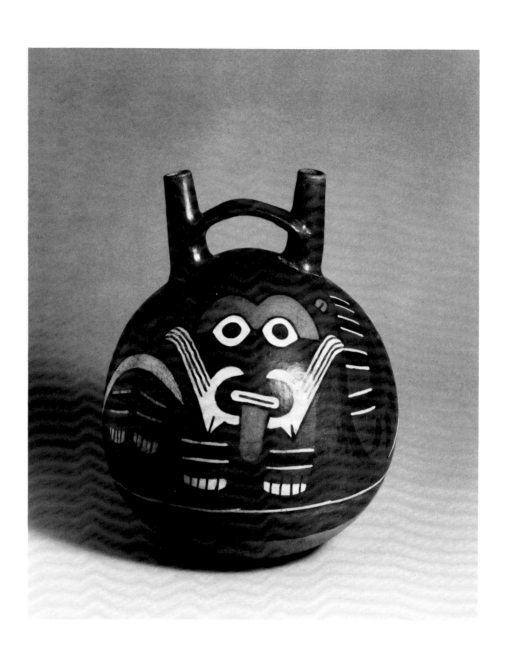

34
Double-Spout-and-Bridge Polychrome Jar
Nazca, A.D. 400-800
South coast, Peru
Orange clay; slipped black, gray, orange, red, and white
H. 20.7 cm
62.180

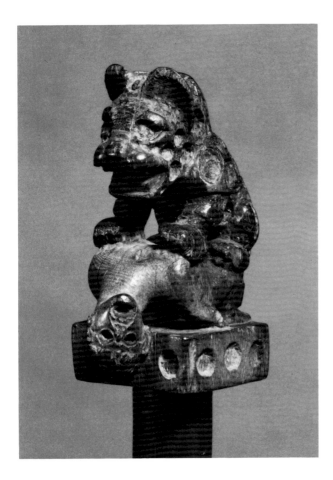

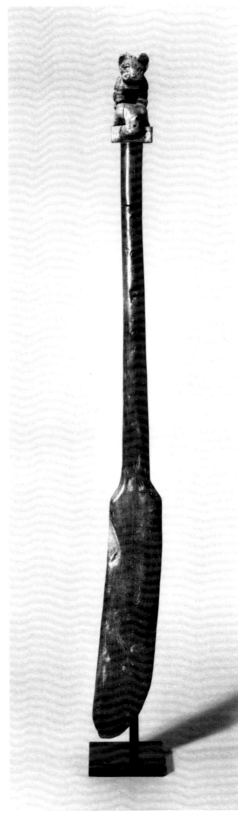

35
Ceremonial Digging Stick
Moche, A.D. 400-800
North coast, Peru
Algarroba wood, copper rivets, resin
H. 137.1 cm
Raymond and Laura Wielgus Collection
100.8.5.75
Former collection of Carmen Oechsle

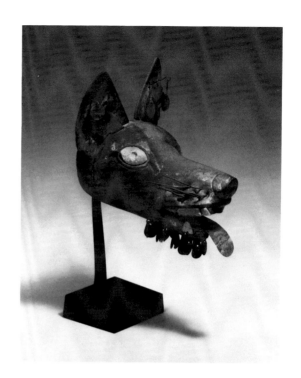

36
Finial in the Form of a Fox Head
Moche, A.D. 400-800
North coast, Peru
Hammered copper, silver wash, shell inlay
L. 15.2 cm
Raymond and Laura Wielgus Collection
100.26.5.79

37
Whistling Jar with Bridged Spout
Lambayeque Valley, A.D. 800-1200
North coast, Peru
Burnished gray clay
H. 22.3 cm
Raymond and Laura Wielgus Collection
75.99.3

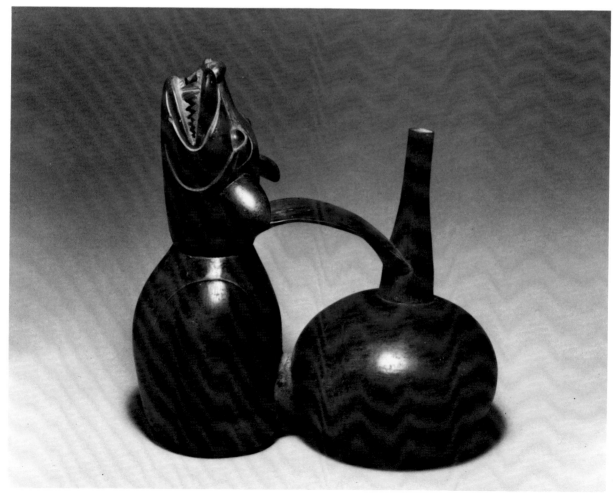

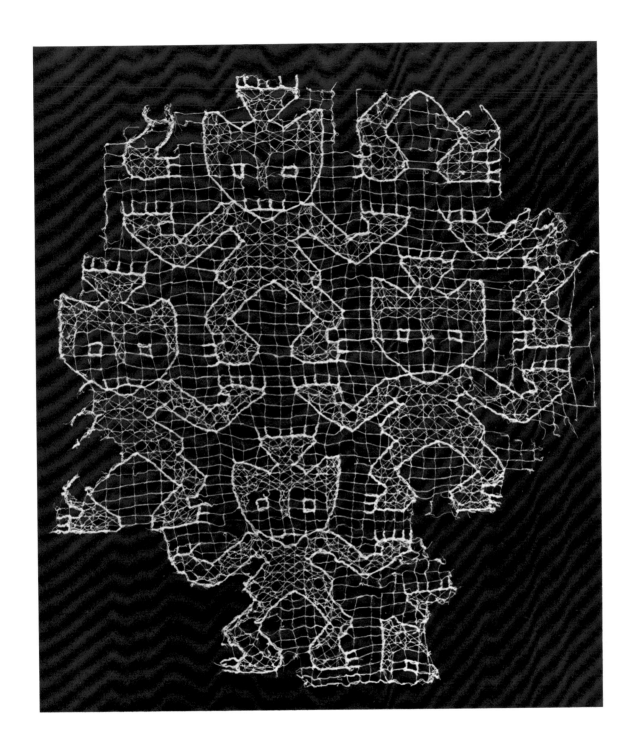

38
Gauze Fragment
Chimú, ca. A.D. 1000
Lauri, Chancay Valley, Peru
Cotton
H. 38.7 cm
72.49.11

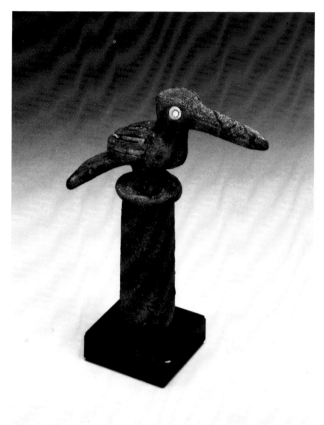

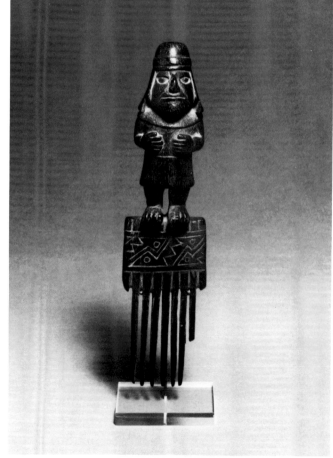

39
Finial in the Form of a Bird
Moche (?) or Chimú (?), A.D. 400-1000
North coast, Peru
Copper, shell
H. 11.5 cm
Raymond and Laura Wielgus Collection
100.24.5.79

40
Comb with Standing Figure
Chimú, A.D. 900-1000
North coast, Peru
Wood
H. 16.5 cm
84.17.2

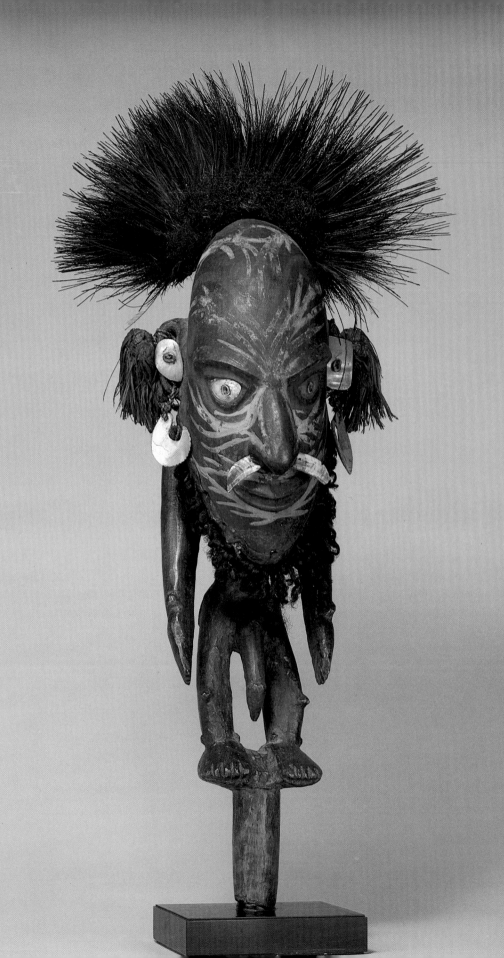

Visual
Arts
of the
Pacific

Douglas Newton

Space, Time, and Population

Works of art from the many areas of the Pacific Islands do not necessarily resemble each other. Certainly we can trace similarities in the styles from New Guinea and the New Hebrides: but in what terms could we compare a figure from the Admiralty Islands with, say, one from Easter Island? The divergencies seem too profound ever to be reconciled. At the same time, except for those inept and ill-realized objects sometimes produced by any school, works from the Pacific have highly defined personalities, sculptural and spiritual, which obviate their being mistaken for the products of any other part of the world. This constellation of styles developed largely as a function of the history of the Pacific Islands peoples. Although they adapted to disparate environments, their cultures nonetheless resonate with certain shared themes with, one might put it, varying harmonics from place to place.

The Pacific is the greatest of the oceans, covering a third of the globe's surface. Its boundaries are the Americas to the east, Beringia to the north, the Antarctic to the south, and the less well-defined border constituted by Asia to the west. Off the coast of Southeast Asia the ocean is broken by groups of large islands, including the Philippines, Sulawesi (Celebes), and the great Indonesian archipelago, the last reaching towards the two major land masses of the Pacific. These are New Guinea, the second largest island in the world, and the continent of Australia. Northeast and east of New Guinea lie several groups of large islands. At a remove of twelve hundred miles from the southeastern Australian coast lie the two islands which constitute New Zealand. The other inhabited parts of the Pacific consist of a

Figure for Sacred Flute
Biwat; Yuat River,
East Sepik Province, Papua New Guinea
ca. 1900-1920
Wood, stone, shell, pearl shell, boar tusk,
human hair, cassowary feathers, fiber, pigment
H. 52.7 cm
Raymond and Laura Wielgus Collection
75.53
Former collection of Paul Chadourne

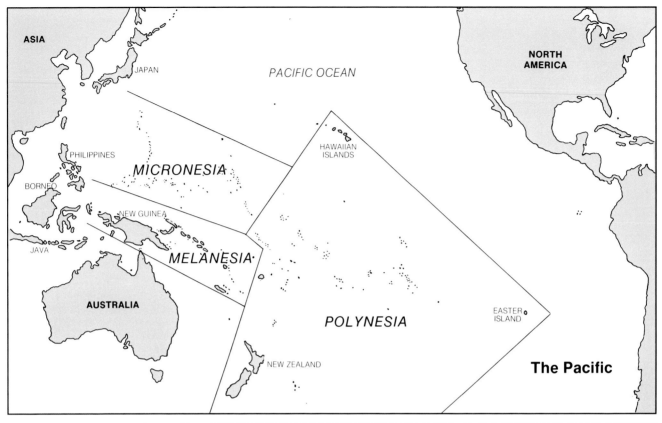

The Pacific

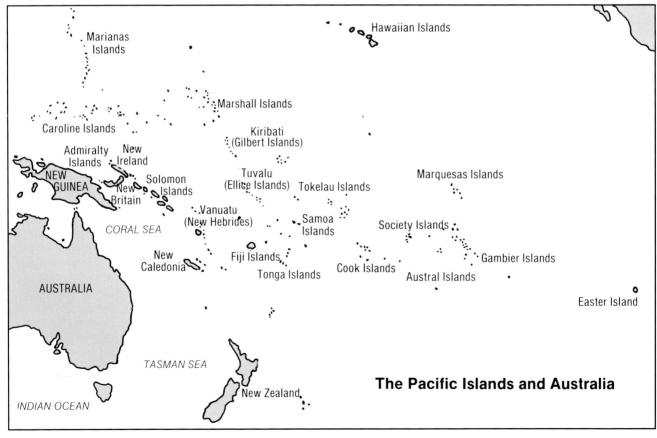

The Pacific Islands and Australia

multitude of lesser islands: either high islands, the peaks of submarine mountains rising above sea level, or atolls, ring-like formations of coral deposited on the rims of submerged volcanic craters.

The island groups were distinguished about 1830 by the French navigator and explorer Dumont d'Urville. In his classification, New Guinea and the nearby islands and island groups—New Britain, New Ireland, the Admiralty Islands, the Solomon Islands, the New Hebrides, and New Caledonia—make up the realm of Melanesia, the "Black Islands." Directly north of New Guinea are two thousand islands with a combined landmass of only one thousand square miles, appropriately called Micronesia, the "Tiny Islands." This includes the Marianas, Marshall, Caroline, and Gilbert island groups. East of Melanesia lie the island groups of Polynesia, the "Many Islands," scattered over about two-thirds of the breadth of the ocean. They are divided into western Polynesia, with the Samoa, Fiji, and Tonga island groups; central Polynesia, with the Cook, Society, and Austral island groups; and, to the north, east, and south, the further Polynesian islands, including the Hawaiian Islands, the Marquesas and Easter Island, and New Zealand.

In recent years, archaeologists have begun to put together a framework for the history of human life in the Pacific, although even now they have been able to investigate only a relatively small number of sites. It is evident, however, that the initial populations of the western Pacific owed their ability to reach the islands to the conditions of the last ice age. During its most severe periods, the cold absorbed so much of the world's water into vast glaciers that the sea level dropped by hundreds of feet, exposing huge tracts of land. Most of Southeast Asia was then a single landmass including Borneo, Sumatra, and Java, now known as Sundaland. Australia, Tasmania, and New Guinea were united in a landmass geographers call Sahulland. The stretches of water between the intermediate islands were far less wide than they are today. By 25,000 B.C. at the latest, people were well established in Australia and New Guinea; but the very first colonists may have arrived ten to fifteen thousand years before, or very possibly even earlier. In what numbers, for what reasons, and how they emigrated are equally unknown. Presumably there were not many voyagers, and possibly their vehicles were as simple as mere bamboo rafts.

When the ocean rose to its present level at the end of the ice age, about ten thousand years ago, the greater expanses of sea between the islands proved a challenge that only people using elaborate watercraft could overcome. The flooding of the Torres Strait between New Guinea and Australia effectively cut off the continent from external contacts, except for some groups in the far north who traded with the islanders of the strait. In both lands the people maintained neolithic hunting and gathering cultures, shifting seasonally to exploit local resources. Some contact between Southeast Asia and New Guinea continued; it led to the New Guineans acquiring new food crops, pigs, and probably agricultural techniques: by 9000 B.C. the people of the central highlands of the island were cultivating the edible root, taro, on a large scale.

The people of New Guinea were speakers of ancestral versions of what are now called the Papuan languages. Some Papuan-speaking migrants moved into the islands of Melanesia by about 6000 B.C. Around 1500 B.C. there was a significant new influx of settlers to Melanesia from Southeast Asia, travelling by means of evidently very efficient sailing canoes. Their languages belonged to the Proto-Oceanic group of the great Austronesian language family found throughout Southeast Asia and as far to the west as Madagascar. Branches of Proto-Oceanic languages spread through parts of coastal New Guinea and the Melanesian island groups, carried by the people who spoke them.

One widespread Proto-Oceanic culture seems to have had a definite identity: it is called Lapita after a site in New Caledonia but also existed in New Britain and the Solomon Islands. The characteristic product of the Lapita culture was pottery with very distinct features: the vessels are fully decorated with geometric (including curvilinear) designs impressed by stamping with toothed wooden implements. In Melanesia, Lapita ceramics are found side-by-side with the products of other local traditions. By 1200 B.C. Lapita pottery was being made in Tonga, and somewhat later in Fiji and Samoa, where it provides the first evidence of human habitation of Polynesia. It is thought that the Polynesian languages evolved here, around 1000 B.C., from the Proto-East Oceanic group. In any case, it was from a western Polynesian homeland that the settlement of the rest of Polynesia began, at about the beginning of the Christian era.

The islands of Micronesia were colonized from both west and south. The Marianas were inhabited by pottery-making people, who probably came from the Philippines, perhaps as early as 1800 B.C. At some unknown date, but certainly by A.D. 1000, immigrants from the same general direction populated the Caroline Islands. The history of the eastern Micronesian islands is more obscure. The cultures have some relations to Polynesia, but it has been suggested that their origins are also to be found in the Lapita culture.

Debates continue as to whether the voyagers who crossed thousands of miles of ocean into further Polynesia did so by accident or on deliberate explorations. Certainly it is likely that some, at least, undertook the adventure knowingly, since they carried with them animals and food-plants as well as other equipment. In either case, their achievement is awe-inspiring. At present, the archaeological record tells us that the farthest island groups from western Polynesia were the earliest to be colonized. The Marquesas Islands, two thousand miles from Fiji, Tonga, and Samoa, were inhabited from about A.D. 300. It appears that about a century later, Marquesans went southeastwards to Easter Island; other Marquesans, after another century passed, settled the Hawaiian Islands far to the northwest. The Marquesas islanders may have made more than one landing in central Polynesia, but certainly they arrived there by about A.D. 600. From the Society Islands, the ancestors of the Maori made the southwestern journey to New Zealand by A.D. 800. It is also possible that, after A.D. 1000, Tahitians travelled to Hawaii and, again, New Zealand. It was not until after 1500 that European navigators, with their advanced shipbuilding technology, began to contemplate such feats of exploration and entered upon the waters of the Pacific Ocean. Effective exploration by Westerners began, at that, only in the eighteenth century; its climax was the work of Captain James Cook, whose three voyages in 1769-1779 pulled together what was known of islands geography and went far towards completing a workable survey of the region.

The first phase of European contact with the Pacific Islands then began, followed soon after by the colonization of Australia by the British. With the rise of the whaling industry, Hawaii and other Polynesian islands became convenient ports of call for the ships of many nations, with consequent havoc wreaked on the cul-

tures. Missionary activity began by the end of the eighteenth century. In Melanesia colonization began, sporadically, about the middle of the nineteenth century, but accelerated in the 1880s with Britain and Germany in competition for western Polynesia, Melanesia, and eastern New Guinea. Neither power attempted much penetration of the interiors of the larger islands. Defeat in World War I ended German ambitions in the Pacific, and Australia assumed control of her New Guinea and Melanesian possessions. Even so, exploration and the spread of European influence went slowly in much of the area; it was not until the 1920s that wide areas of New Guinea were brought under even nominal control, while the large populations of its central highlands were only so much as discovered in the 1930s.

There has been, then, a disjunction in the degree of westernization in the Pacific as a whole until recently. Some areas have been exposed to the West for over two centuries, others only for a few decades. Increasingly the countries are becoming independent nations, and there is a rising concern in a number of them for the maintenance and renewal of tradition.

Traditional Cultures

The material culture of the Pacific peoples was generally based on a neolithic technology. Only in the last few hundred years were insignificant quantities of metal introduced to northwest New Guinea from eastern Indonesia, and these metal objects did not circulate very far. Stone blades were the main tools, supplemented by shell scrapers, bamboo blades, and animal teeth. With these the islanders embarked on massive programs of architecture and boat-building, both of which reached high levels of accomplishment. Numerous crafts were practiced, including pottery, mat-making, and netting for use and decoration. Weaving on small back-strap looms was done only in Micronesia and the Santa Cruz Islands; flax fiber was also woven into cloaks in New Zealand. Elsewhere "cloth" was made from paper-mulberry bark, quite often—especially in Polynesia—in huge quantities.

There were nomadic populations of hunters and gatherers in Australia, and some groups of semi-nomads in New Guinea. The majority of the Pacific islanders were agriculturalists living in well-established villages that varied in size from hamlets to the fortified hilltop settlements of the New Zealand Maori. The availability of the

main crops (sago, taro, yam, sweet potato) was determined by the different environments. These crops were supplemented by domesticated or wild strains of banana, coconut, and pandanus. Some of the introduced animals, particularly pigs, lived on a fine line between the domesticated and the feral. Hunting produced small amounts of edible game, particularly birds; fishing provided a major food supply on the coasts and along the rivers.

Typically, generalized accounts of Pacific Islands societies draw a picture of stark contrast in which Melanesian and Polynesian institutions, temperaments, and concepts are seen as almost diametrically opposed. They do in fact show considerable variation. Melanesian societies, very broadly speaking, are acephalous, with men gaining status and merit by virtue of passing through complex systems of initiation. The episodes can be spread over the whole course of a man's life, they may involve severe physical ordeals, and they usually include the revelation of religious secrets. The Melanesian supernatural world is one of spirits associated with natural phenomena, with some emphasis on the powers of ancestors. Religious knowledge and ritual are largely, if not exclusively, secrets of males; this division is part of a powerful syndrome of intersexual avoidance that extends so far in many Melanesian societies as to entail institutionalized homosexuality. Male aggression is still highly valued; war, headhunting, and sometimes cannibalism were endemic.

The contrast between Melanesia and Polynesia perhaps may be mediated by a view of the Maori who, it will be remembered, moved to New Zealand around A.D. 800 and possibly retained early Polynesian traits. The Maori, too, stressed aggression with concomitant warfare, headhunting, and cannibalism, and to a certain extent practiced the ritual exclusion of women. On the other hand, they followed Polynesian models in many essential respects. The supernatural world of the Polynesians included a pantheon of gods and goddesses. The great creator divinities each patronized an aspect of the world and human activities; but there were also many lesser localized gods as well. Society was a hierarchy headed by chiefs, or even rulers, wielding broad and arbitrary power by virtue of their heritages of ancestral prestige. Below them were ranked in descending order specialists, commoners, and sometimes slaves.

Artists ranked among the specialists in all Pacific Islands societies. They stood apart from the man of common skills who could always, at a pinch, shape his own paddle, hook, or bowl. They were often believed to wield supernatural power, or at least to have intimate connections with the supernatural world through visions. Women often performed craftwork, weaving and plain pottery, but practically speaking carvers and painters were always men. The artists worked as individuals on smaller personal projects, but they also acted as masters and guides to teams of less esteemed assistants on large-scale efforts, particularly when architectural schemes were being carried out.

New Guinea

The closest of the Pacific Islands to Southeast Asia, New Guinea was nevertheless singularly unaffected by Asian ideologies and historical processes except in the relatively small area in the far northwest where intermittent trading with some of the nearer Indonesian islands took place. Trading never extended to the rest of the fifteen-hundred-mile-long island, even though a small number of Malay hunters of birds of paradise ventured somewhat further. Some carvings from the northwest reflect the styles of nearer Indonesia, but the rest of New Guinea maintained its integrity. The inhabitants of the island, about three million people, produced enormous quantities of paintings, sculptures, ceramics, and other works in a great variety of styles found in a large number of clearly distinguishable style areas. The north and south coasts of the western part of New Guinea, a former Dutch possession now politically part of Indonesia (under the name Irian Jaya), are among these areas; but it is the lowlands and coasts of the eastern division of the island, the independent country of Papua New Guinea—including the Sepik Provinces, the Gulf of Papua, and the Massim area—which are particularly fertile art-producing regions. The people of the central highlands, though the major part of the population, specialized in lavish body decoration but produced little permanent art.

The most famous of the New Guinea style areas is that large proportion of northeastern New Guinea comprising a huge river valley lying between a coastal range to the north and the foothills of the central highlands to the south. This includes the East and West Sepik Provinces. The valley is drained by the Sepik River, which flows through it from the west for about eight hundred miles,

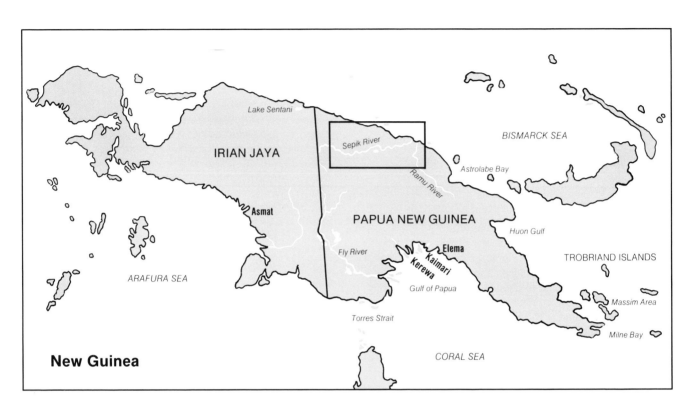

New Guinea

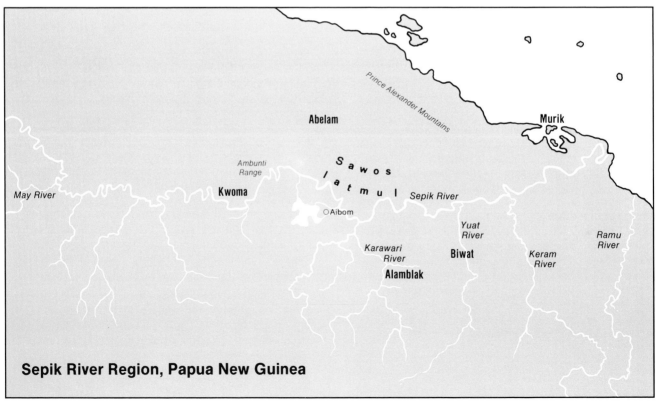

Sepik River Region, Papua New Guinea

and by its many tributaries. The Sepik's mouth is close to that of a lesser river, the Ramu, which flows from the south through a similar, smaller valley.

The population, about 350,000 people, speak over two hundred different languages, nearly all Papuan. The hill areas, where the majority lives, are broken, rugged, and jungle-covered. The valley floor is an enormous flood-plain, under water for part of the year. It sounds an unlikely environment for the cultivation of the arts, yet it is reasonably favorable; in many areas—particularly along the rivers, with their stocks of fish and nearby stands of sago palms—a relatively small investment of labor ensures ample food supplies. Consequently a great deal of time was available for non-utilitarian activi-ties: art and religion. Hence the fame of the Sepik area peoples for their splendid architectural feats and copious production of wood sculptures, paintings, and ceramics. Even here not all groups were equally aesthet-ically fertile. The most productive were the speakers of the Ndu-family languages: the Abelam and Boiken of the Prince Alexander Mountains north of the river, and the Sawos of the swamps and the Iatmul of the middle river lands, altogether some eighty-nine thousand people. The people of the lower Sepik were nearly as active; and striking sculptures and paintings were created by people of the southern tributaries.

Not only the largest group in the area, with forty thou-sand people, the Abelam were the most prolific of all. Elaborate initiatory cults and cults concerned with the growth and fertility of yams centered on the ceremonial houses, among the most spectacular in the Pacific. Their gables towered to ninety feet, almost completely covered on the exterior with arrays of bark paintings (no. 41). The interiors were stacked with sacred carv-ings, as for instance those of women with parted legs through which initiates crawled in symbolic rebirth (no. 42). In public performances men wore basketry masks representing female water-spirits; smaller woven masks were placed on yams during public displays of the crops (fig. 1; nos. 43 and 44).

The smaller Sawos and Iatmul groups had similarly splendid cultures and a passion for elaboration that also extended to non-religious art. Both also maintained complex ceremonial that occupied a great proportion of the men's time. The excitement and pride of display, as well as the religious fervor stirred by these activities, enhanced the impetus to warfare and headhunting.

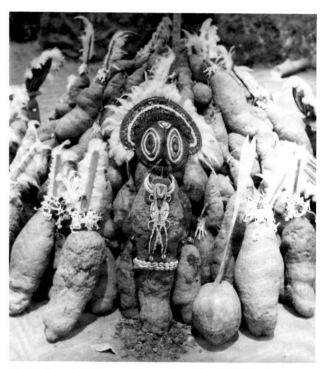

Fig. 1 Yam display in an Abelam village, East Sepik Province
Photo courtesy Museum für Völkerkunde, Basel

Masks of many types abounded, including large bas-ketry costumes representing ancestors and totemic animals.

It is on the northeast coast of the East Sepik Province, around the mouth of the river and along the lower stretches of the river, that we find the famous figures and masks with enormously extended noses produced by the Murik people and other groups (no. 45). Probably these features are references to avian ancestors or spir-its. These styles, unlike those of the Ndu-language people, tend to be crisp, precise, and even somewhat mechanical. Masks and dances were, in any case, popu-lar commodities in an extensive coastal trading complex into which the Murik people fed their production of these works.

The most dynamic figure sculptures of all New Guinea may well be the small male images (color plate, p. 48) from the Biwat (or Mundugumor) people of the Yuat River, a southern tributary of the lower Sepik. Originally

the figures were plugged into the ends of large bamboo flutes, sacred musical instruments associated with mythological crocodiles. Their crouched posture, their disproportionately large heads and glowing shell-inlaid eyes, are expressive of pure aggression consistent with the ethos of a people notable for their harshness and violence even in the context of other Sepik cultures.

The forest-covered hills south of the Sepik River are the home of several styles of sculpture that play variations on a single conception: a series of hooks, along a narrow spine, which are concentric to a central element. Traces of this style are also found as more-or-less prominent features in carvings from the east—the Keram and Yuat rivers, and even the Ramu River—and among the Abelam north of the Sepik. Probably in these areas what remains is the survival of a style that was once much more widespread. In the southern hills this style existed in a pure, completely abstract variation among a number of small groups of people, some of whom were semi-nomadic.

The Alamblak of the Karawari River seem to have been influenced in fairly recent times by Iatmul culture, including the war and headhunting cult. The major spirits of the Alamblak are patrons of headhunting and animal hunting called *yipwon,* embodied in carvings of the concentric hook type, but also each endowed with a human head and a single leg. Individual men owned pocket-sized examples that they carried in their bags of personal property (no. 46); larger carvings, which could range up to ten feet high, were the collective posses-sions of clan-groups (no. 47).

The Ewa, who lived to the south of the Alamblak, have been almost exterminated by epidemics. Their carved figures had the same general significance and form, but in a distinctively different style. The elements corres-ponding to the graceful, simple hooks of *yipwon* also include panels, spirals, and other forms engraved with surface patterns and densely fringed with vertical spikes. The flat profile figures (no. 49) are all male spirits; fully modeled frontal figures with upraised arms (no. 50) represent one of a pair of mythical women. Some Ewa carvings may be a few hundred years old; they owe their excellent state of preservation to having been deposited, with the bones of their owners, in dry limestone shelters.

Fig. 2 Kwoma dagger (no. 51)

Apart from carvings, the Alamblak also used during initiation ceremonies a special type of conical basketry mask with long nose and circular eyes (no. 48). These were probably made by the neighboring Kapriman people, who also traded them to the river people and other tribes to the west. For themselves the Kapriman made huge basketry masks to be placed in the gables of their houses.

The minor arts of the Sepik are often refined and ele-gant. Daggers and spatulas (nos. 51, 52, 53) of human or cassowary bone are incised with delicate designs that reflect those of the much larger bark paintings (fig. 2; cf. no. 41). Such objects were often intended to be as much magical as military. Wealth was held in the form of shell ornaments. This tradition was a very ancient one: marine

shells are known to have been traded inland for great distances from six thousand years ago, and they have retained their glamour as part of marriage and other payments into recent years. Pottery was a highly important craft throughout New Guinea; but, in accord with the general artistic genius of the Sepik people, it was their vessels that showed the greatest decorative virtuosity. The products of several pottery-making centers, such as Aibom village of the Iatmul people and the settlements of the eastern Sawos people (no. 55), were treasured possessions and were traded up and down the river for a couple of hundred miles.

By contrast to the creative exuberance of the Eastern Sepik Province peoples, the arts of the Western Sepik Province are relatively modest. There was a certain amount of bark painting, incorporated into masks, using simple abstract or zoomorphic motifs. Sculpture was practically nonexistent: the nearest approach to it appears in the simple designs, engraved or relief, on shields. In an expanse of territory running from the hinterland of the northern coast south to the central mountain ranges, the almost universal design is built around the pattern of a Maltese cross, sometimes with subsidiary motifs in the angles. Perhaps the simplest version—certainly the most graceful—is a group of coils representing a water-spirit (fig. 3) used by the Olo in the north. A stricter angularity characterizes the shields (no. 56) and door panels of the southern mountain people.

Two peripheral areas of Papua New Guinea with important and distinctive art styles are the Huon Gulf and the Massim area, both inhabited by Austronesian-language speakers. The Huon Gulf, cutting into the eastern coast, had a remarkable center for carvers on the Tami Islands; their elegant bowls were a staple of a coastal trading system that extended to southern New Britain. Their carvings (nos. 57 and 58) are built up with massive, cubistic forms enlivened by sharp triangles in relief, which even on a small scale convey a brooding sense of weight and power.

The carvings of the Massim area are in complete contrast to those of the Huon Gulf. Numerous groups of large and small islands off the southeast end of Papua New Guinea, and part of the mainland itself, are loosely integrated in the remarkable trading system called *Kula*, which still survives. Its ostensible purpose is to circulate two types of shell valuables through the island chains, each in the opposite direction to the other. Along with

these valuables, however, the traders carry quantities of food and manufactures for barter, including particularly the small lime spatulas carved in the Trobriand Islands. The spatulas (no. 59), of black wood inlaid with contrasting white lime, show human and stylized bird figures with rounded forms and curvilinear incising. Splash-boards and projecting carvings (no. 60) set at both prows and sterns of the trading canoes also incorporate these motifs, even though the images virtually disappear amid the graceful, swirling scrolls that dominate the designs. Intensely decorative though they are, the canoe carvings (which show variations from group to group of islands) symbolically function as powerful protective and aggressive devices on behalf of the canoe's passengers and their hope for success in the *Kula*.

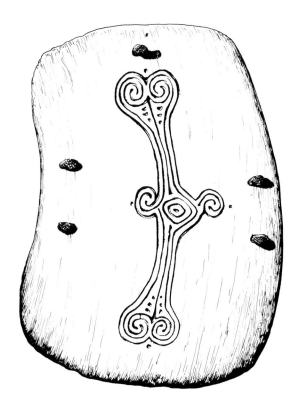

Fig. 3 Olo shield, West Sepik Province
H. 101.6 cm; IUAM 76.127.1

The Gulf of Papua spans some two hundred miles of the central south coast, largely surrounded by a vast swamp drained by a multitude of creeks and large rivers. The many local groups were headhunters, and most were cannibals. To the east they tended to live in villages clustered around ceremonial houses shaped like immensely long half-cones laid flat. The people to the west built longhouses that could accommodate an entire community, flanked with small structures for domestic life.

The art of the Gulf of Papua is predominantly two-dimensional, except for some rare figure sculpture made in the far west. All the eastern groups made large numbers of oval or lanceolate boards (often cut from the sides of old canoes), carved in shallow relief with human figures or human faces above clusters of abstractions representing the limbs. The boards were kept in rows in the shrine-like compartments into which the ceremonial houses were divided, often below racks of ancestral or captured skulls (fig. 4). The designs portrayed not so much actual ancestors as protective spirits.

Among the Kerewa tribe, the boards (*gope*) were usually carved with a single figure, its knees bent and its arms upraised (no. 62). They include a type of object unknown anywhere else: flat, half-length figures with long spikes rising from the waist between the arms and the torso. These *agibe* (no. 61) were racks for skulls suspended from the uprights and were particularly pow-erful paraphernalia of the headhunting cult. The *gope* of other groups have more complex abstract designs, generally units that individually are simple, but, in groups, set up lively visual rhythms. These abstractions appear also on some small silhouette figures that, in this area, were placed alongside the trophy skulls.

The gulf people made a number of different types of masks, all of basketry, sometimes covered with painted barkcloth. While some types are three-dimensional, others maintain the essentially two-dimensional tradi-tion: they show the same tall, oval forms, the same patterns. Ultimately, perhaps, this obsessive use of a single form is a knowing hint, a half-revelation, about the greatest ritual secret of these tribes: the sacred oval bull-roarers that were swung to produce the booming voices of the sea and forest spirits.

To the west of the Gulf of Papua, within the territory of Irian Jaya, live the Asmat. Like the gulf tribes, the Asmat

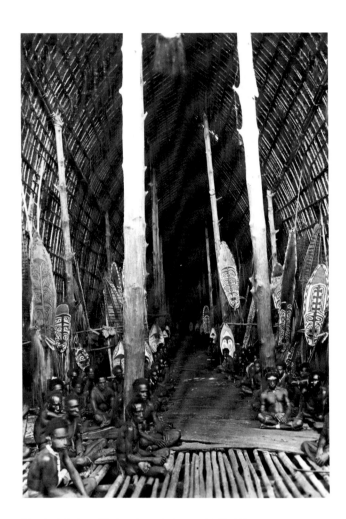

Fig. 4 Interior of Kaimari men's house, Gulf of Papua
Photo by Capt. Frank Hurley, 1924
Courtesy American Museum of Natural History

are swamp and river dwellers with a vendetta-like obsession with revenge. Their insistence on the repayment of death by death, coupled with the belief that no death was natural—if not caused by violence, it must be the result of sorcery—led to a state of constant warfare. This was not unusual in New Guinea and Melanesian societies. But what was peculiar to the Asmat was a myth that human beings were originally created as wooden statues brought to life by the sound of a sacred drum. Figure sculpture forms a large component of Asmat art. As with Asmat shields, bowls, canoes, weapons, and trumpets (no. 63), the figures are usually basically simple forms covered with abstract incised or relief design elements that symbolize objects and beings associated with headhunting.

Island Melanesia

The groups of large islands that make up Melanesia run from northeast of New Guinea in a southeasterly direction. While the inhabitants have in common the fact that they speak Austronesian languages—with the exception of a few groups in the interiors of some islands—the cultures are remarkably disparate. Each island group has a different style, or group of styles; and each seems to express one or another cultural theme, which again varies from group to group.

To take the culture of the Admiralty Islands, the most northerly, first, one finds a marked contrast with the religious orientation of New Guinea art. Cults of the dead indeed exist—the skulls of ancestors are stored in special wooden bowls and exercise a minatory function against wrong-doers—but most of the abundant woodcarvings and decorative objects were secular in purpose and use. Most, in fact, were the work of a single group, the Matankor, who lived on the coast of Manus, the largest island. They carved huge feast bowls with spiral handles, slit-gongs, house-ladders, beds and other furniture, lime spatulas, spears, daggers fitted with obsidian blades, and feathered war-charms (no. 64), all of which they traded to the inland Manus people and to the people of the smaller islands. Some life-size figures were also carved, and these may possibly have had religious significance. The main subjects of Admiralty Islands sculpture are in fact humans and, sometimes, crocodile heads in a standardized and rather lifeless convention. The characteristic overall red coloration, with details in black, is, however, enlivened by bands of triangles or diamonds in white.

If a single theme runs through the ideology of the peoples of New Ireland, it was the celebration of death. The passing of important men was marked by feasts, lengthy rituals, and the display of carvings. The island is about two hundred miles long, but is mostly less than twenty miles wide and is largely one extended mountain range, with peaks reaching seven thousand feet. Practically all settlement lies along the coast. There are three major art areas: the northwest, the central area around the Lelet Plateau, and the Namatanai area of the southeast. The sculpture of the northwest without doubt shows the greatest virtuosity in all Oceanic art. It consists of wood carvings: masks, figures, and long openwork frieze-like objects. All were commissioned from recognized master-artists for commemorative ceremonies for the dead: ceremonies and carvings were known by the same term, *malanggan. Malanggan* festivals often took place years after a death, as the preparations entailed the accumulation of quantities of valuables for payments and distribution. Not only mourning was involved, but the display of power; and as so often in such cases (one thinks of the art of the Northwest Coast of America), the art affirms a spirit of sheer ostentation.

An individual *malanggan,* generally carved from a single piece of wood, usually shows a human figure, or several figures standing one above the other, on a human or animal head, in an aggressive, angular style. Around the figures is likely to be a cage of detached bars. In other *malanggan,* figures may be standing in a canoe, rising from the mouth of a fish, turning their heads, or gesturing (nos. 65 and 66). Between the figures there may be

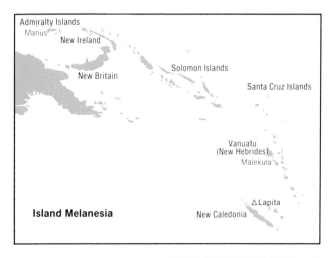

perforated panels supporting freestanding groups of birds, animals, and cosmic symbols. The whole already complex form was finished with surface painting in white, red, black, and yellow in which broad areas of color are diversified with patches of busy, fine-line cross-hatching. Some *malanggan* were up to twenty feet long. Displayed in groups against specially constructed screens, they were powerful affirmations of the splendor of the ancestral heroes and their feats (fig. 5). *Malanggan* feasts were also the occasion for the initiation of young men, who thus symbolically replaced the dead of the clan; they appeared in dance masks (*tatanua*) of similar, if simpler, style. Ironically, the end of all this magnificence was the abandonment of the carvings to decay: they were never used again.

In the middle part of the island, around the Lelet Plateau, the central objects in the cult of the dead were nearly life-sized figures called *uli* (no. 67). In contrast to the swarming imagery of *malanggan, uli* show a heavy austerity. Short legs support a bulky torso and massive, crested head. The face has a grimacing mouth and prominent hooked nose. The *uli* have in common with *malanggan* eyes set with the opercula of sea-snails,

which gives them commanding, glaring expressions, stressed by minatory gestures of their upraised hands. Like *malanggan*, too, *uli* are sometimes caged within frameworks of bars. They are simply painted, mostly white with dark red or black faces. *Uli* are hermaphroditic, with male genitalia and female breasts. While they represented male ancestors, they simultaneously demonstrated the ancestral powers of fertility as well as successful aggression in this literal and summary manner.

The sculptures of the Namatanai area are mainly chalk figures (no. 68) of the ancestors, modest in size and simple in execution. Both males and females are depicted, standing with their hands held at their chests. Their coloration is minimal, consisting of no more than small areas of patterning in red and black. Also used in death cults, groups of them were housed in small special shelters.

The shoreline of New Britain, to the south of New Ireland, is ringed with Austronesian-speaking groups. In the hilly interior, however, live non-Austronesian-speaking groups, the best known being speakers of dialects of the Baining language. Baining art primarily

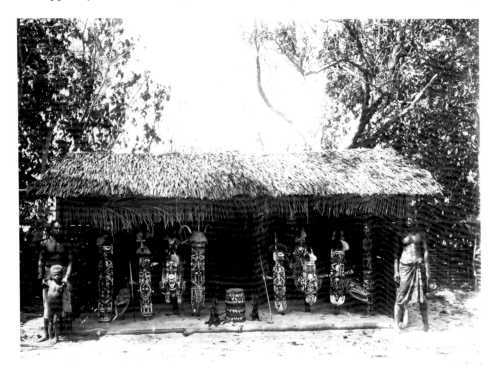

Fig. 5
Malanggan display, New Ireland
Photo by Felix Speiser, 1930
Courtesy Museum für Völkerkunde
Basel

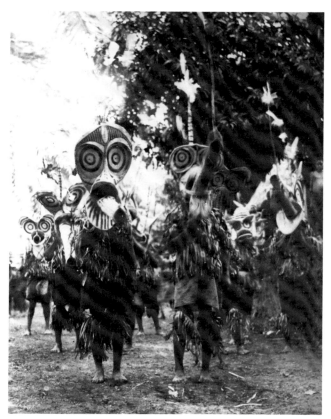

Fig. 6 Baining *kavat* masquerade performance, New Britain
Photo courtesy Museum für Völkerkunde, Basel

Fig. 7 Feather currency, *tevau*
Dia. 49.9 cm; IUAM 80.42

consists of masks and headpieces, of painted bark-cloth stretched over light wood frames, used in dances held in the daytime or at night. The night-dance masks called *kavat* (no. 69) were worn by performers carrying snakes (later eaten) who rushed through bonfires—an obscure ritual, seemingly related to the activities of men as hunters (fig. 6).

The Solomon Islands chain consists of about ten island groups large and small, inhabited by people with diverse cultures. Some of the islands have been inhabited for about four thousand years, while the Santa Cruz group, to the southeast, has Lapita sites from about 1200-600 B.C. Most of the languages are Austronesian, with enclaves of Papuan languages in the northern and some other islands. Within the last few hundred years, a couple of the small outer islands were colonized by Polynesians.

The villagers lived largely by agriculture and fishing, which in certain areas was accompanied by considerable ritual. The communities were led by chiefs, sometimes hereditary. Art styles were as diverse as the cultures. It can be said, however, that while sculpture was often left unpainted, throughout the Solomons the favorite color was black with occasional touches of red. This somber effect was enlivened by bands of X- or triangle-shaped inlaid pieces of iridescent nautilus shell. One is inevitably reminded of the decoration of Admiralty Islands and even Huon Gulf carvings. The most famous works are the small busts (nos. 70 and 71), tutelary spirits attached to the tall prows of the huge war canoes of the central Solomon Islands. Shell beads were used in quantities for ornaments and belts that were a form of currency. A unique valuable, also employed in payments for brides and canoes, was the red feather band (fig. 7) made in Santa Cruz.

To the south again, in the New Hebrides, one encounters once more a variation on the tradition of extended initiation, in this case the aim being the attainment of elevated rank. Male society was structured in a series of ascending grades, each with its own title. The assumption of each rank entailed its own rituals, the sacrifice of pigs bred to have abnormally outsized tusks, and the carving of commemorative figures (no. 72). Again according to the grade involved, each of these figures was of a prescribed material (wood or fernwood), form, and style of painting. Such figures were kept in shelters at the borders of dance-grounds that stretched in front

of the ceremonial houses. These dance-grounds were also the sites of huge vertical slit-gongs carved with human heads, which were beaten with complex rhythms during the grade-ceremonies.

Smaller carvings included graceful canoe prows (no. 73) from the coast of Malekula, the major island, and some of the smaller islands to the northeast. They represent, in an extremely stylized manner, single or paired frigate birds.

The southernmost island of the Melanesian chain is New Caledonia, like New Ireland a long, narrow range of mountains with a border of lowland coast. The styles of sculpture are, however, unlike any others from the whole area. In the first place, very few forms were made, comparatively speaking. They consist mainly of architectural sculptures for the steeply conical houses of the chiefs, including tall finials, door jambs, and lintels; there are also some independent figures. Masks, only used in the northern part of the island, have short, broad noses or enormous curved beaks. The universal color of New Caledonian sculptures is black, with a few touches of red; a somber scheme which enhances the power of the ferocious, geometricized features of the masks (no. 75) representing ancestors and water spirits. Short staffs mounted with discs of green jade (no. 74) were the insignia of important men and are said to be cosmic symbols.

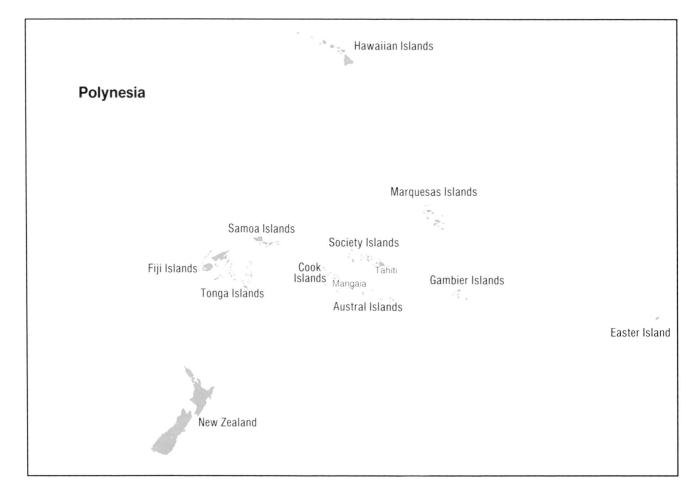

Polynesia

Hawaiian Islands

Marquesas Islands

Samoa Islands

Society Islands

Fiji Islands

Cook Islands

Tahiti

Gambier Islands

Mangaia

Tonga Islands

Austral Islands

Easter Island

New Zealand

The Polynesian Triangle

The development of Polynesian culture began in the Fiji, Tonga, and Samoa groups of islands, which throughout their history maintained contacts between each other. The Lapita pottery tradition in these islands continued as decorated ware until 400 B.C. and as undecorated ware thereafter, finally disappearing at the beginning of the present era. Pottery was not again manufactured in Polynesia until much later, in Fiji. By an early date there seem to have been stonefaced royal burial mounds, platform mounds for communal buildings, large open spaces for religious ceremonials, and fortified sites. The stratification of Polynesian society begins to be reflected in these structures. Material culture included adzes and fishhooks in shapes new to the Pacific Islands, and spatulate hand clubs. Ornaments such as shell discs look back to Melanesian prototypes; decorative hooks and whale-tooth pendants emerge as something new. Following the dispersal of migrants throughout the islands, many local developments occurred; but many themes of Polynesian culture remained fairly constant.

Our knowledge of Polynesian art, with the exception of New Zealand's and to some extent Hawaii's, is very incomplete. Most of what has survived is small in scale, and there is, in any case, not a great deal of it. Early drawings and written accounts by European explorers record types of sculptures that do not exist in any known examples, as well as works in known styles but on a very large scale. The losses, at least in part, are due to the destruction of religious and other works of art carried out by missionaries, or by islanders following their example, in the early nineteenth century. Sheer obsolescence accounted for the disappearance of many things, such as the magnificently decorated war-canoes of Tahiti, and probably some architectural sculpture. The picture is further distorted by the plethora of certain kinds of portable objects that, from an early period, were made for sale to visitors. They include Fijian clubs, the mounted adzes of the Cook Islands, the decorated paddles of the Austral Islands and, somewhat later, figures from Easter Island. Other types of objects, still made for traditional use—such as Hawaiian ivory hook-pendants (no. 90) and New Zealand jade pendants (no. 82)—increased in size due to a new abundance of material and the introduction of European tools.

One notable quality of Polynesian art is an elegant simplicity of unadorned form that is particularly evident in western Polynesia; bowls for the ceremonial drink, *kava*, and priests' dishes for oil are often fine examples. The main weapons were clubs (nos. 76 and 78) for hurling or wielding, made in an astonishing number of different-named forms, each carefully calculated to inflict a specific kind of wound. Figure sculpture from these islands is now rare and was probably always small-scale; about a dozen superb ivory pieces a few inches high survive, most of which were carved in Tonga and traded to Fiji (fig. 8), as were composite gorgets of ivory and shell.

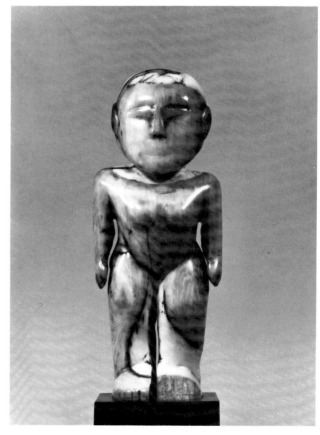

Fig. 8 Whale ivory pendant in the form of a female figure
Haapai group, Tonga Islands; h. 12.7 cm
Raymond and Laura Wielgus Collection
Photo courtesy Raymond Wielgus

A considerable degree of surface decoration was prevalent in some of the Cook Islands. Among the best-known examples are the symbols of gods from Mangaia in the form of hafted adze-blades with shafts entirely covered with simple but dense cross-hatched patterns in relief (no. 77). (It was these adzes, given columnar or rectangular cross-sectioned bases, which became such popular items for sale.) A similar impulse to elaborate, repetitive surface decoration characterizes the magnificent standing drums (no. 79), a half-dozen of which were collected from the Austral Islands in the early nineteenth century. The tall cylindrical shafts below the resonating chambers are carved partly in openwork, with alternate registers (in the present case) of figures of dancing women and crescents indicating dance skirts. These are surely among the greatest displays of sheer virtuosity in carving to be found in the Pacific area.

To some extent they are matched in the more recent art of the New Zealand Maori. "Maori," the name of the first settlers of New Zealand, means "natural" or "normal": it is expressive of the isolation that—certainly like many other Pacific islanders—they experienced for hundreds of years, and which produced a highly individual culture. Arriving from eastern Polynesia perhaps in the ninth century, the Maori were forced to make rapid adjustments to their new environment. Food plants such as banana and coconut that might have been brought from the tropical homeland were simply not viable in the temperate climate of the north and south islands of New Zealand. The only animals the Maori ancestors imported were dogs and rats.

At first they settled on the coasts, which offered them a wealth of sealife, while the land provided not only vegetable resources but the moa, a huge ostrich-like bird, now extinct. At some point new immigrants brought the sweet potato, which had somehow reached other Polynesian islands from the New World. A greater reliance on agriculture developed, as did the creation of fortified settlements that bespeak a spread of warfare.

There are tantalizing specimens of sculpture and ornaments from those early periods that seem to give us a hint of what early Polynesian art was like elsewhere: types of human figures, for instance, and the serration of edges that faintly recall the traditions of the Lapita potters. At the same time, they also demonstrate a development towards a combination of the smooth forms of Polynesia with fluid, curvilinear designs, quite different from the geometric patterning of the Cook or Austral islands.

This change culminates about the middle of the seventeenth century in the Classic Maori style with which we are most familiar, since it has flourished to the present day. The style is brilliantly expressive of a proud, ambitious society with its hierarchies of power, elaborate protocol, and devotion to warfare and cannibalism.

The Maori expressed their ambition, power, and prestige through heroic projects: war canoes that could carry dozens of warriors, large storehouses, and meeting-houses that could accommodate the whole village and its guests. All of these were lavishly decorated with carving and painting. Canoes were fitted with towering stern-posts, fashioned in openwork scrolls; the prows were equipped with panels of scrolls behind forward-plunging figures with raging, outthrust tongues (no. 81). If their specific symbolism has been lost, their message of dynamic energy and menace is still unmistakable. Meetinghouses symbolized the bodies of the ancient ancestors; accordingly, the architectural members of the houses represented parts of their anatomy: spines, arms, and heads. Wall-panels inside the houses, and small figures set above the gables (no. 84) recalled a myth about the origin of sculpture: the sea-god Tangaroa kidnapped a son of the hero Rua, in revenge for the boy's irreverence, and fastened him to the gable of his house. Rua searched for his son, and, when he found him, burned Tangaroa's house, first stealing some of the carvings.

Power was also manifest in the small jade neck-pendants called *tiki* (no. 82). Jade itself, with its rich color and intense hardness, was so valued that wars were fought for control of its sources in the South Island. Individual *tikis* had personal names, and the names of their past owners were preserved in tradition.

The material equipment of the Maori was relatively simple, but it included a number of objects that were often exquisitely carved: flutes (no. 83) of several types attest both to the Maori's love of music and to their precious small-scale workmanship.

The art styles of the remaining areas of marginal Polynesia—the Marquesas Islands, Hawaii, and Easter Island—show striking contrasts to each other in sculptural form and degree of surface decoration. In the Marquesas Islands the latter predominates. The clubs (no. 85) are incised with designs that recall those of the Aus-

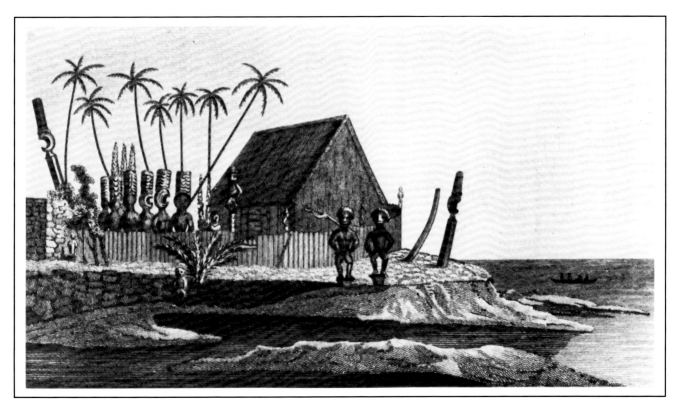

Fig. 9 Hale-o-Keawe, burial site of Hawaiian kings
From William Ellis, *Journal of William Ellis, Narrative of a Tour of Hawaii . . .*, 1825 (repr. 1979)

tral Islands in their precision and regularity. Among them are systems of circles, semicircles, and horizontal lines or bands that are arranged into simple stylizations of human faces and hands. By their nature these configurations are readily adaptable to the two-dimensional representations of human beings on the tortoise-shell panels of diadems (no. 86) or on cylindrical bone ornaments (nos. 87 and 88).

The Hawaiian Islands were dominated by courtly societies whose rulers and nobles warred on each other until, just before European intervention, the military genius of the great Kamehameha had gone far towards uniting the group into a single realm. The warriors were figures of extraordinary splendor, wrapped in feather cloaks and capes emblazoned with heraldic designs in brilliant reds and yellows, and capped with feathered helmets resembling the Roman pattern. At their necks they wore ivory hook-pendants (no. 90), survivals of similar pendants that had been used in much more ancient times in other Polynesian areas. Large heads of the war-god Kuka'ilimoku, made of basketry covered with sacred red feathers, were carried into battle. Wooden images of gods (no. 89) were kept in special buildings within the bounds of sacred enclosures, while other huge wooden figures stood in the open (fig. 9).

The most isolated place in the eastern Pacific Ocean is Easter Island, 1250 miles from its nearest Polynesian neighbor and double that distance from the coast of the New World. Consisting of little more than three extinct volcanoes and the valleys between them, the island is windswept and barren to an extent that suggests overpopulation and catastrophic over-exploitation of the environment. In any case, between the twelfth and seventeenth centuries the inhabitants were numerous enough to embark upon the making of the famous six to seven hundred stone colossi, adorned with red stone topknots and glaring shell eyes, which have haunted western imagination since the island was discovered. They seem, whatever their actual significance, like hypertrophied descendants of the temple-images from other parts of Polynesia. Small wooden carvings from the island are even stranger, and far more eccentric in a Polynesian context. The most remarkable are the bowed figures of skeletal men (no. 91) that were worn as pendants in dances, and that apparently represent ancestors.

Micronesia

There are two thousand islands in Micronesia; a measure of their average size can be gathered from the fact that three of them—Guam, Ponape, and Babel-

thurap—comprise about 465 square miles, while the rest, mainly atolls, amount to only about 635 square miles. Among them the Micronesian islands support about 130,000 people. The societies were complex caste-systems headed by chieftains; material culture was simple. Sculpture, so major a feature of the art of other Pacific islands, was rare in Micronesia; it is found only as architectural carvings from the Palau Islands and as small figures (no. 92) and canoe prows from a few other areas.

Micronesian artistry was usually expressed in craftwork of exceptional refinement. Among the most striking Micronesian achievements are vegetable fiber weavings worked in minute strips on small back-strap looms. These strips were used as loincloths or belts or were pieced together to make women's skirts. Plaited mats are technically coarser than the weavings but are elegantly designed. Personal adornments included many types of headgear, enhanced by flowers, face paints, and tattooing. Even tools, household equipment and other minor objects (no. 94) share a graceful simplicity and sense of balance that is the essence of Micronesian art and that links it to similar aspects of Polynesian products.

Australia

Australia has not only been inhabited longer than any other part of the Pacific, it has yielded the earliest evidence for creation in the visual arts. Walls in Koonalda Cave, in southern Australia, are covered with linear markings, some apparently random, some in regular groups, which are about twenty thousand years old; similar markings in other caves may also be as old. Ochre was being used by at least eighteen thousand years ago for coloration of some sort, and certain rock paintings are thought to be more than seven to nine thousand years old. Rough representations of animal tracks, eggs, and enigmatic pictograms pecked into wide rock surfaces were made from seven thousand years ago onwards.

These and other archaeological traces are enough to show that Australian art, over many thousand years, was abundant and varied, leading up to the wide range of regional styles practiced in historic times. These were a reflection of an extraordinary wealth of religious belief and ritual. The ease with which food could be obtained by hunting and gathering, employing a simple but fully adequate technology, provided these nomadic people with ample leisure for large-scale ceremonies involving song, dance, and sometimes the participation of hundreds of people. Much of the paraphernalia involved was ephemeral: sculptures in earth or sand, paintings on the soil, fantastic body decorations of paint and bird-down. Among the more permanent relics are such wooden objects as bull-roarers (no. 93) and sacred boards (no. 95) with patterns commemorating sacred places or the actions of mythological ancestral beings.

Present and Future

The traditional arts of the Pacific Islands, as we know them, with rather few exceptions—some archaeological discoveries, the Easter Islands stone giants, and so on—date only from the last 250 years. Future research is quite likely to extend this period, as can be seen from the scanty, but impressive, excavated material from New Zealand and parts of Melanesia, more of which will no doubt appear as investigation goes on. Nothing like the full record will ever be known: the islanders made too extensive a use of perishable materials, if their recent techniques are any guide to their practice in the past.

What is happening to the arts of the Pacific now, and what will take place in the future? The present picture is one of uneven productivity, geographically speaking: negligible in some places, almost hectic in others. The breakdown of traditional systems, combined with the massive influx of physical and intellectual novelties, besides actual alien populations, has had the effect of diversifying the contemporary visual arts into several new directions. There are modifications of traditional forms, the "evolved traditional" styles that are partly due to changing social needs and the use of new tools, and these can include cross-adaptations of traditional styles. Perhaps most visible of all are the "airport arts," designed for distribution through commercial channels, and adapted specifically for commercial requirements and expectations. Besides all these, younger artists are working in strictly western media—paper, oils, metal—in new styles that often combine traditional imagery with contemporary imagery filtered through western techniques. Overall, the scene is animated by great, if somewhat random, vitality. The arts of the Pacific are in a period of transition—to what, we can only wait to see.

Suggestions for Further Reading

Aboriginal Australia. Text by Carol Cooper et al. Sidney, 1981.

Archey, Gilbert. *The Art Forms of Polynesia.* Auckland, 1965.

—————. *Whaowhia, Maori Art and Its Artists.* Auckland, 1977.

Barrow, Terence. *Art and Life in Polynesia.* Rutland, Vt., 1972.

—————. *The Art of Tahiti and the Neighboring Society, Austral and Cook Islands.* London, 1979.

Bellwood, Peter. *Man's Conquest of the Pacific.* New York, 1979.

Berndt, Ronald M., ed. *Australian Aboriginal Art.* London, 1964.

Berndt, Ronald M., and E. S. Phillips, eds. *The Australian Aboriginal Heritage.* Sidney, 1973.

Buhler, Alfred; Terence Barrow; and Charles P. Mountford. *The Art of the South Sea Islands.* New York, 1962.

Corbin, George A. "The Primitive World; South Pacific Art." *Encyclopedia of World Art* 16 (New York, 1983), pp. 9-15.

Force, Roland W. and Maryanne Force. *The Fuller Collection of Pacific Artifacts.* New York, 1971.

Gathercole, Peter; Adrienne L. Kaeppler; and Douglas Newton. *The Art of the Pacific Islands.* Washington, 1979.

Gerbrands, A. A. *Wow-Ipits.* Hague, 1967.

Guiart, Jean. *The Arts of the South Pacific.* New York, 1963.

Jennings, Jesse David, ed. *The Prehistory of Polynesia.* Cambridge, Mass., 1979.

Mason, Leonard. "Micronesian Cultures." *Encyclopedia of World Art* 9 (London, 1964), pp. 918-30.

Mead, Sidney M., ed. *Exploring the Visual Arts of Oceania.* Honolulu, 1979.

—————. *Te Maori.* New York, 1984.

Mead, Sidney M., and Bernie Karnot. *Art and Artists of Oceania.* Palmerston North, N.Z., 1983.

Newton, Douglas. *New Guinea Art in the Collection of the Museum of Primitive Art.* Greenwich, Conn., 1967.

Schmitz, Carl A. *Oceanic Art: Myth, Man and Image in the South Seas.* New York, 1971.

Waite, Deborah. *Art of the Solomon Islands from the Collection of the Barbier-Müller Museum.* Geneva, 1983.

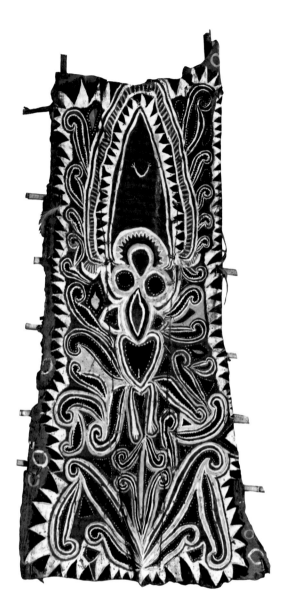

41
Gable Painting for Men's Ceremonial House
Abelam; Prince Alexander Mountains,
East Sepik Province, Papua New Guinea
Bark, bamboo, pigment, feathers
H. 175.9 cm
63.62

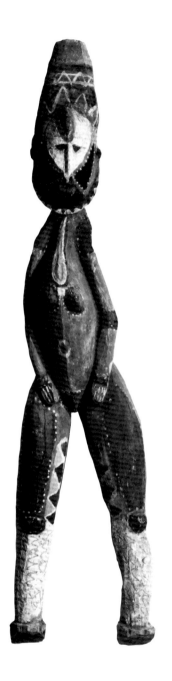

42
Initiation Figure
Abelam; Prince Alexander Mountains,
East Sepik Province, Papua New Guinea
Wood, pigment
H. 135.9 cm
63.68

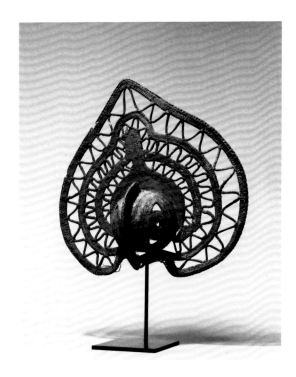

43
Yam Mask
Abelam; Prince Alexander Mountains,
East Sepik Province, Papua New Guinea
Fiber, pigment
H. 35.5 cm
63.76

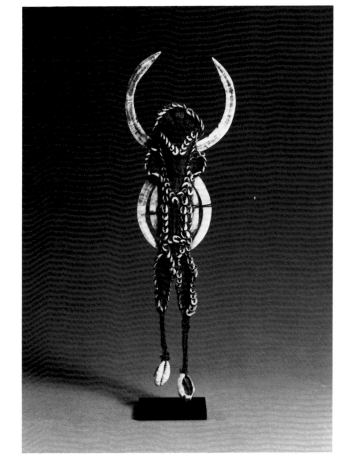

44
Ornament, *kara ut*
Abelam; Prince Alexander Mountains,
East Sepik Province, Papua New Guinea
Fiber, ivory, shell, pigment
H. 29.7 cm
Raymond and Laura Wielgus Collection
100.29.5.79

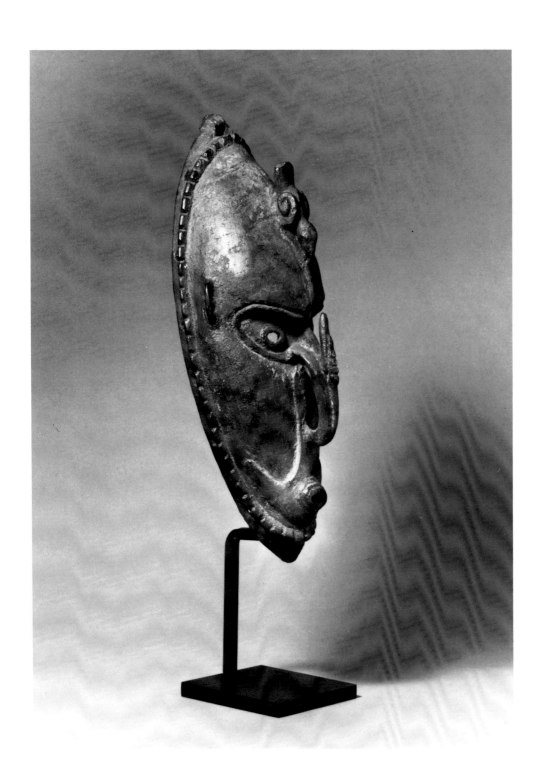

45
Mask
Murik
East Sepik Province, Papua New Guinea
Wood
H. 40.4 cm
80.64

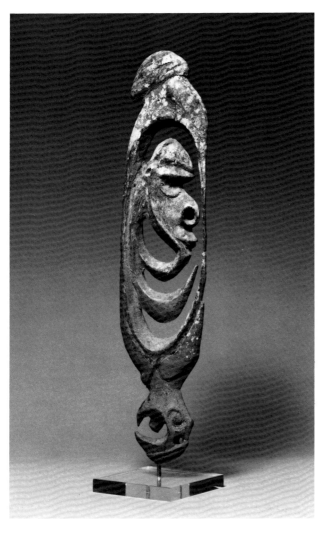

46
War and Hunting Amulet, *yipwon*
Alamblak; Karawari River,
East Sepik Province, Papua New Guinea
Wood, pigment
H. 38.1 cm
80.34

47
War and Hunting Spirit Figure, *yipwon*
Alamblak; probably Yanitobak village, Karawari River,
East Sepik Province, Papua New Guinea
Wood
H. 207 cm
75.31

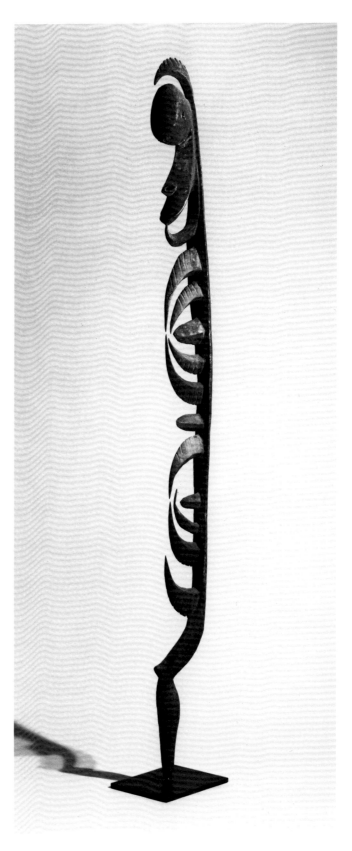

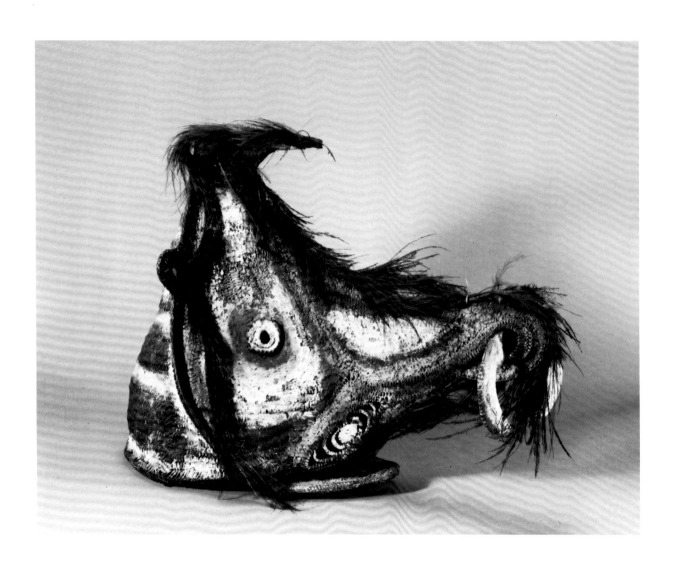

48
Mask, *didagur*
Kapriman; Karawari River,
East Sepik Province, Papua New Guinea
Fiber, pigment, feathers
H. 62.2 cm
63.70

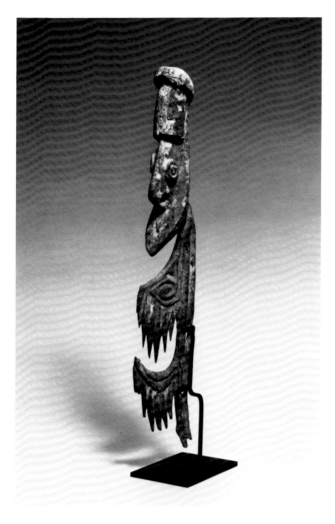

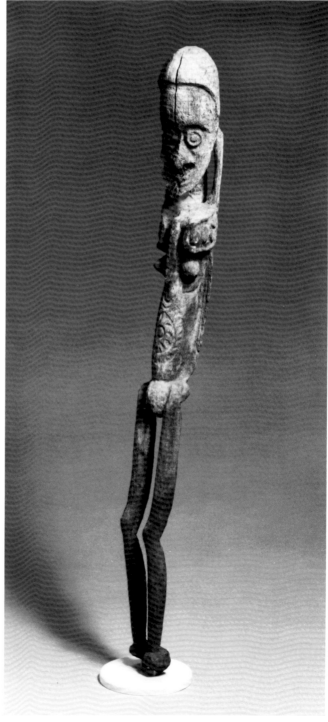

49
Fragment of a Carving, *aripa*
Ewa; East Sepik Province, Papua New Guinea
Wood
H. 55.2 cm
79.50

50
Female Figure
Ewa; East Sepik Province, Papua New Guinea
Wood
H. 99 cm
80.33

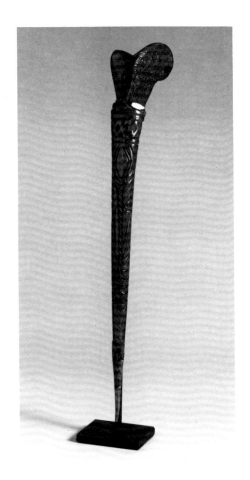

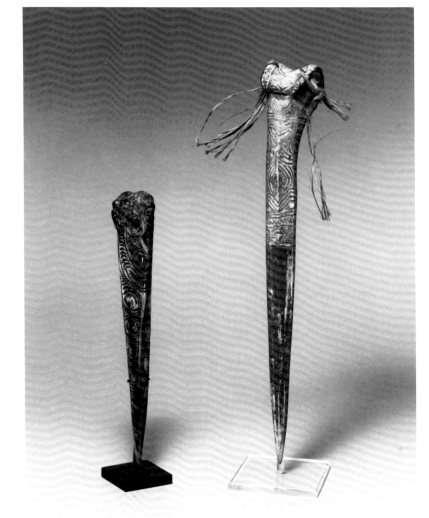

51
Dagger
Kwoma; Ambunti Mountains,
East Sepik Province, Papua New Guinea
Human femur bone
L. 33.6 cm
Raymond and Laura Wielgus Collection
66.72

52
Dagger
Iatmul
East Sepik Province, Papua New Guinea
Cassowary bone
L. 25.7 cm
Raymond and Laura Wielgus Collection
75.99.2

53
Dagger
Abelam; Prince Alexander Mountains,
East Sepik Province, Papua New Guinea
Cassowary bone
L. 36.2 cm
63.73

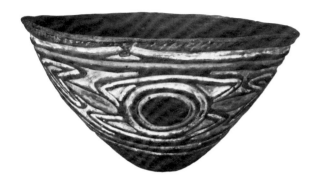

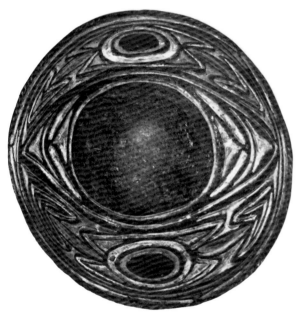

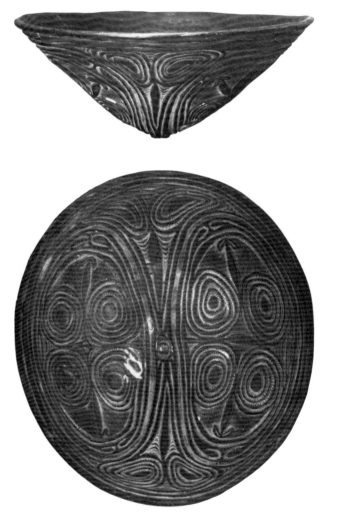

54
Bowl
Boiken; Toanumbu,
East Sepik Province, Papua New Guinea
Clay, pigment
Dia. 30.7 cm
63.81

55
Bowl
Sawos
East Sepik Province, Papua New Guinea
Clay, pigment
Dia. 35.1 cm
74.42.2

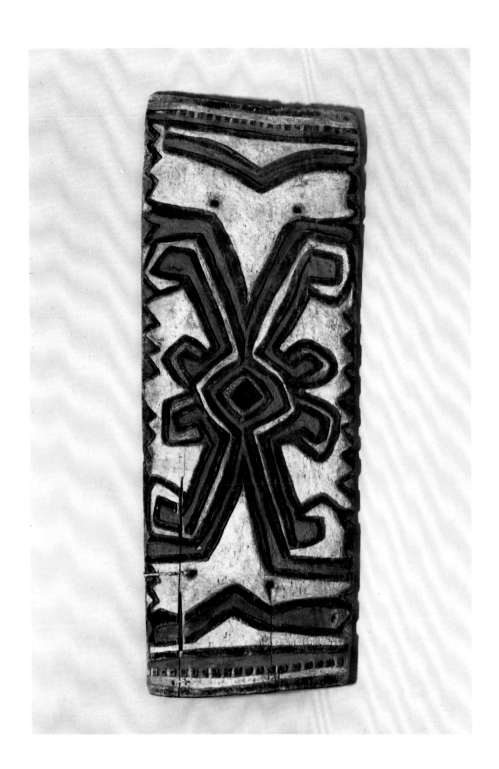

56
Shield
Telefol
West Sepik Province, Papua New Guinea
Wood, pigment
H. 171.4 cm
78.6

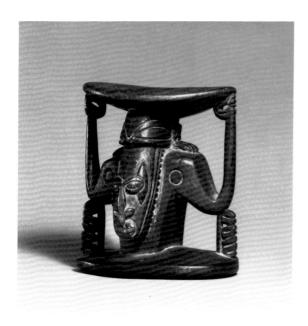

57
Headrest
Tami Islands, Huon Gulf,
Morobe Province, Papua New Guinea
Wood
H. 12.6 cm
Gift of Dr. and Mrs. Henry R. Hope
74.29.2
Former collection of Néprajzi Múzeum, Budapest

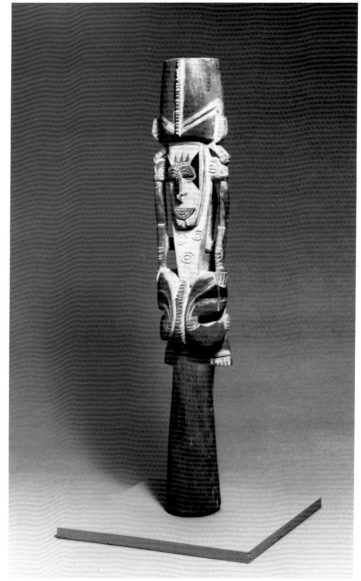

58
Figure
Tami Islands, Huon Gulf,
Morobe Province, Papua New Guinea
Wood, pigment
H. 83.8 cm
Gift of Dr. and Mrs. Henry R. Hope
74.29.1
Collected by Lajos Biró in 1900;
former collection of Néprajzi Múzeum, Budapest

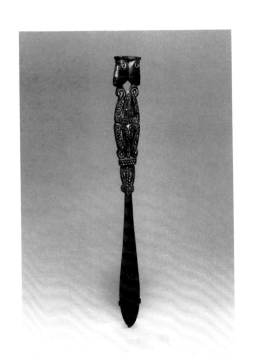

59
Lime Spatula, *kena*
Trobriand Islands,
Milne Bay Province, Papua New Guinea
Wood, pigment
L. 35.8 cm
Gift of Rita and John Grunwald
78.57.6

60
Canoe Prow, *tabuya,* **and Splash Board,** *lagim*
Trobriand Islands,
Milne Bay Province, Papua New Guinea
Wood, pigment
H. 47.6 cm, L. 67.9 cm
71.13.3. a & b

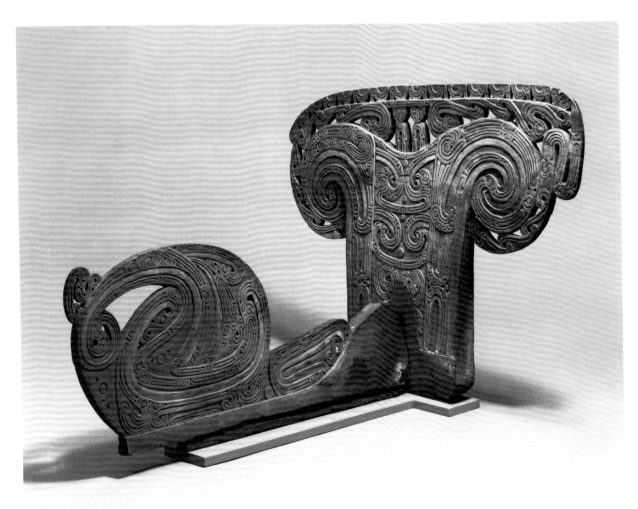

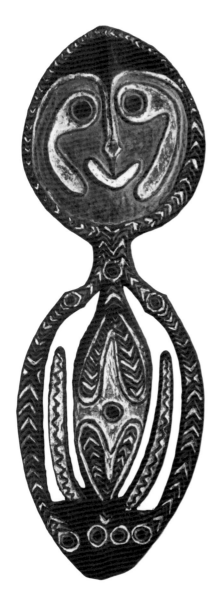

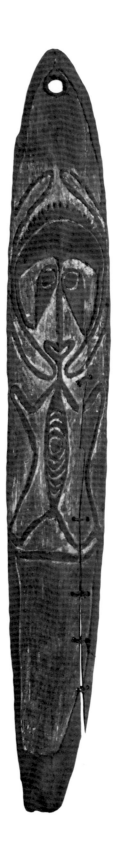

61
Skull Rack, *agibe*
Kerewa
Gulf Province, Papua New Guinea
Wood, pigment
H. 85.6 cm
80.72.1

62
Board, *gope*
Kerewa
Gulf Province, Papua New Guinea
Wood, pigment
H. 111.7 cm
76.42.1
Collected by Dr. William Patten in March, 1912

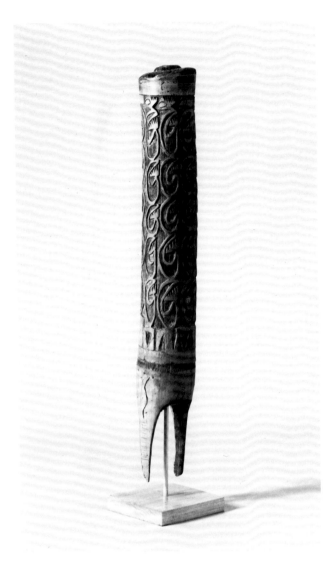

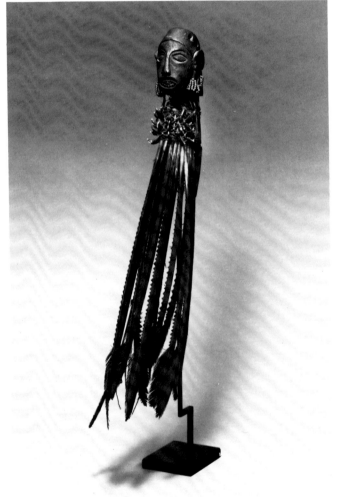

63
Trumpet
Asmat, Keenok group
Upper Pomats River, Irian Jaya
Wood
H. 54.6 cm
63.66

64
War Charm
Matankor; Manus Island,
Admiralty Islands
Wood, frigate bird feathers, beads,
teeth, cloth, fiber
H. 52 cm
76.40

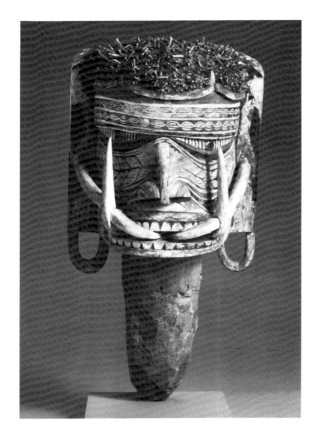

65
Memorial Carving, *malanggan*
New Ireland
Wood, pigment, resin, sea-snail opercula
H. 49.8 cm
64.124
Collected by Richard Parkinson ca. 1890;
former collection of Museum für Völkerkunde, Dresden

66
Memorial Carving, *malanggan*
New Ireland
Wood, pigment, fiber, sea-snail opercula
H. 74.9 cm
81.17

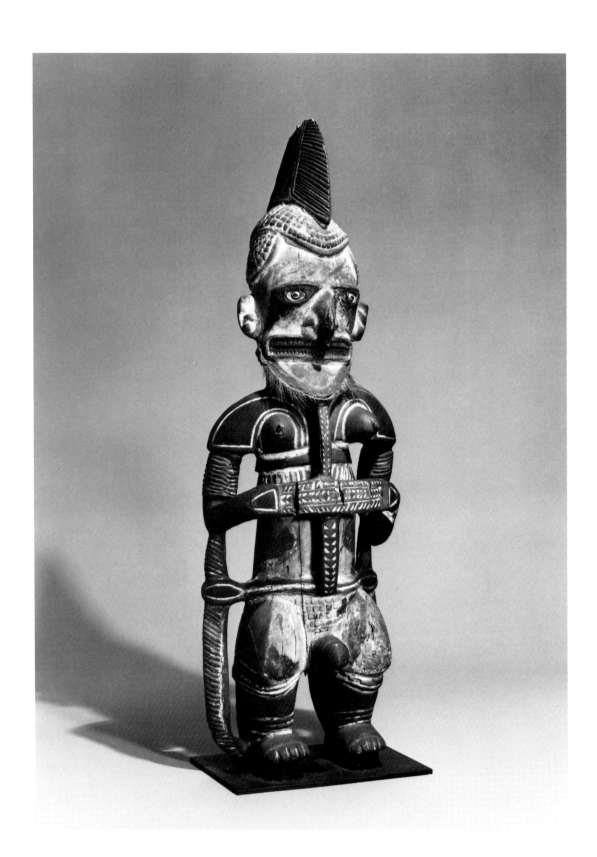

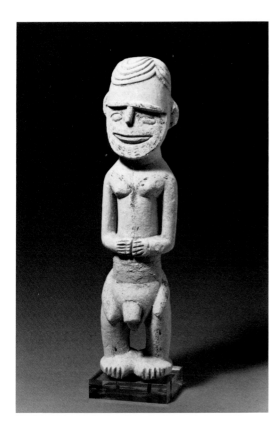

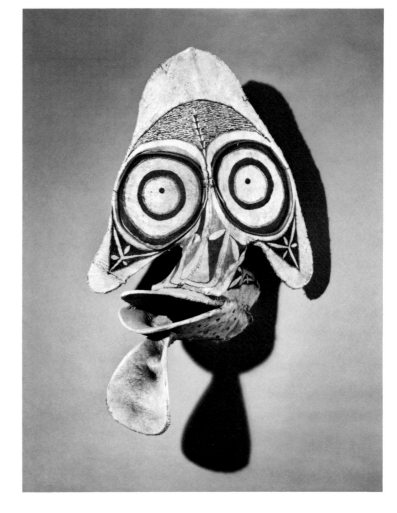

68
Figure
Namatanai area, New Ireland
Chalk, traces of pigment
H. 44.1 cm
62.67

69
Night-Dance Mask, *kavat*
Baining; New Britain
Bark cloth, bamboo, pigment
H. 102.9 cm
76.45

◀ 67
Memorial Figure, *uli: lembankakat egilampe*
Northern Mandak
Malom, Lelet Plateau, New Ireland
Wood, pigment, sea-snail opercula, fiber
H. 139.7 cm
Raymond and Laura Wielgus Collection
100.1.80
*Published in A. Krämer, <u>Malánggane von Tombára</u>, Munich, 1925;
former collections of Linden-Museum, Stuttgart,
and Serge Brignoni*

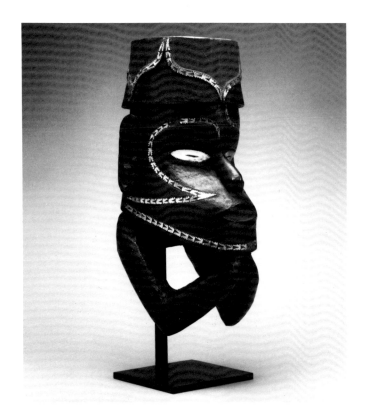

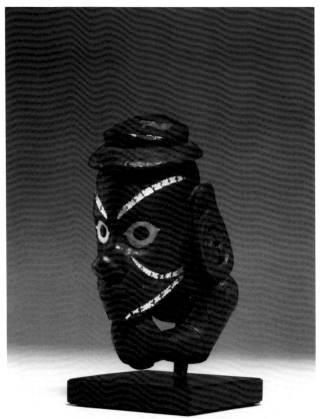

70
Canoe Prow Ornament, *nguzu nguzu*
Solomon Islands
ca. 1800-1900
Wood, pearl shell, pigment
H. 13.7 cm
Raymond and Laura Wielgus Collection
100.6.5.75

71
Canoe Prow Ornament, *nguzu nguzu*
Solomon Islands
Wood, pearl shell, pigment
H. 28.6 cm
75.51

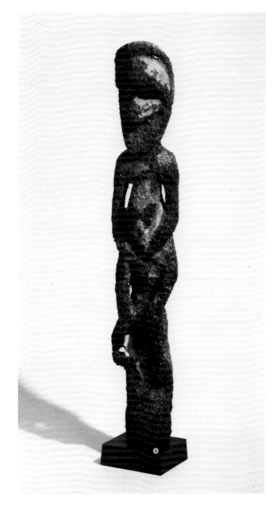

72
Grade Society (*mangi*) Figure
Ambrym Island, Vanuatu (New Hebrides)
Fernwood, clay
H. 97.7 cm
Raymond and Laura Wielgus Collection
63.285

73
Canoe Prow Ornament
Malekula Island, Vanuatu (New Hebrides)
Wood
L. 94.6 cm
80.115

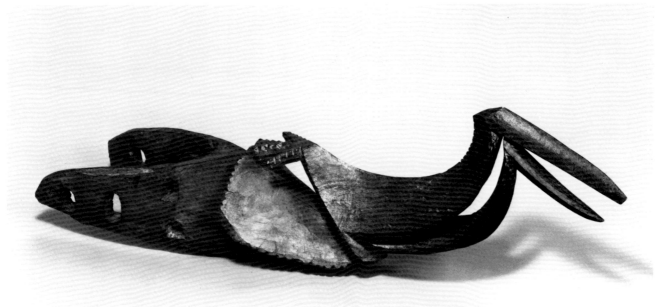

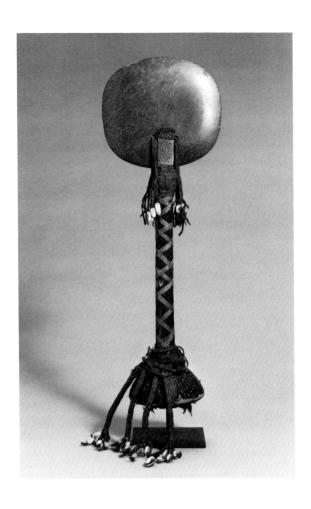

74
Ceremonial Staff, *gi okono*
New Caledonia
Nephrite, wood, fiber, cotton cloth, shells
H. 66.6 cm
74.77.1

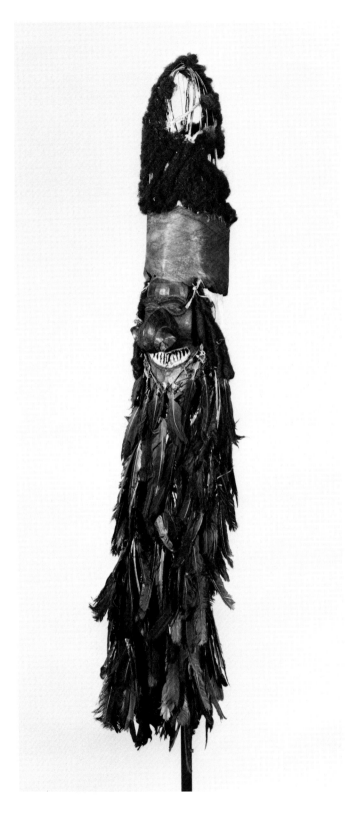

75
Mask, *apouema*
New Caledonia
Wood, feathers, hair, fiber, pigment
H. 156.7 cm
74.77.2

76
Throwing Club, *i ula tavatava*
Fiji Islands
ca. 1800-1900
Wood
L. 41.8 cm
Gift of Ernst and Ruth Anspach
71.83.1

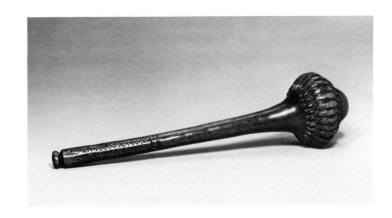

77
Adze
Cook Islands
Wood, basalt, fiber, sharkskin
L. 83.1 cm
74.43.2

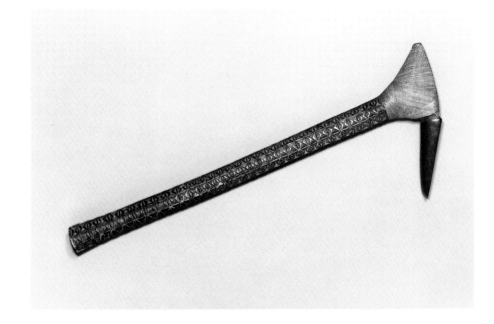

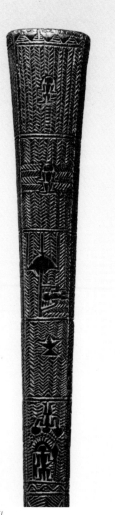

78
Club, *apa'apai*
Tonga Islands
Wood
L. 94.3 cm
77.34.5
*Former collection of
Frederick R. Pleasants*

detail

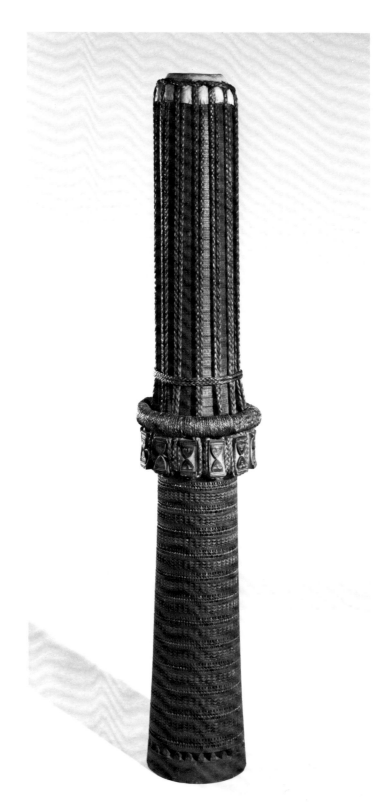

79
Drum, *pahu-ra*
Austral Islands
ca. 1800-1850
Wood, sharkskin, fiber
H. 137.1 cm
Raymond and Laura Wielgus Collection
80.5.3

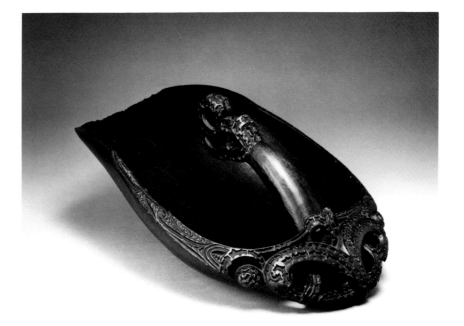

80
Canoe Bailer, *tiheru*
Maori, Te Whanau-a-Apanui style of Tukaki,
Rongowhakaata group
North Island, New Zealand
Te Puawaitanga period, ca. 1500-1800
Wood
L. 44.8 cm
75.67

81
Canoe Prow Ornament
Maori; North Island, New Zealand
Wood, pearl shell
H. 48.2 cm, L. 92 cm
65.35

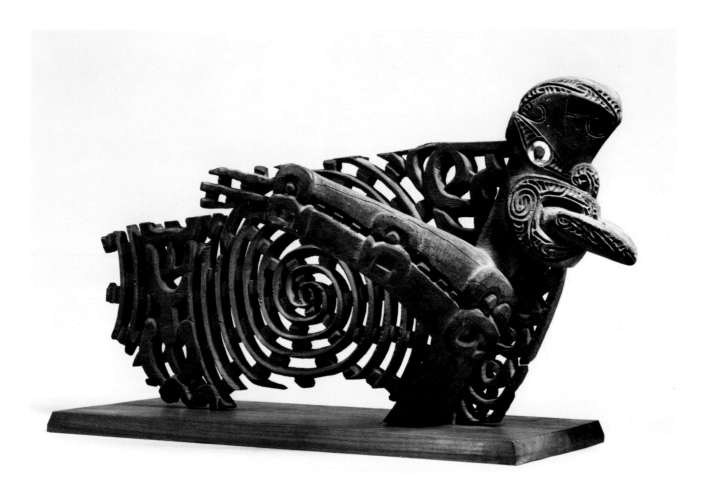

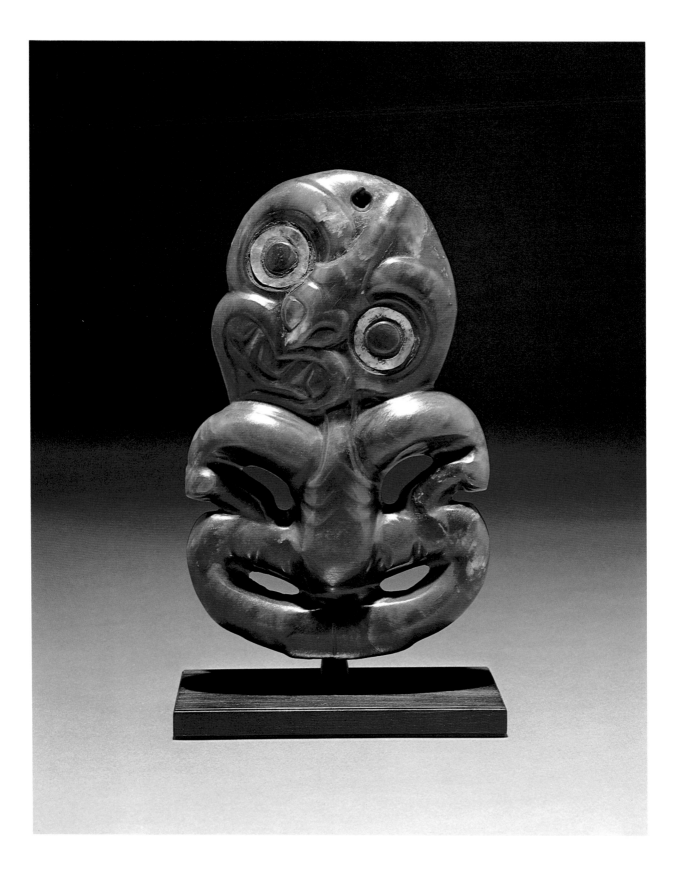

83
Flute, *koauau*
Maori; Taranaki area, North Island,
New Zealand
Wood, haliotis shell
L. 19.2 cm
Raymond and Laura Wielgus Collection
100.21.5.79

84
Gable Ornament, *tekoteko*
Maori, Ngati Rautu group
Patea, North Island, New Zealand
Wood
H. 38.1 cm
66.75

 82
Pendant, *hei-tiki*
Maori; New Zealand
ca. 1800-1900
Nephrite, haliotis shell
H. 22.5 cm
Raymond and Laura Wielgus Collection
80.5.2
Former collection of Sir Jacob Epstein

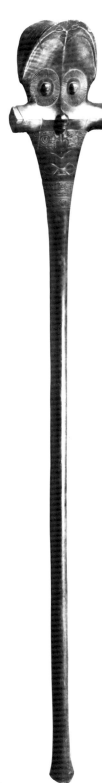
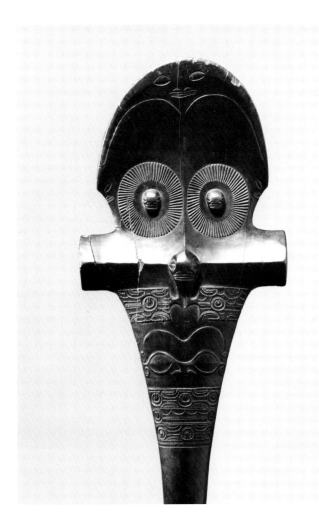

85
Club, *u,u*
Marquesas Islands
ca. 1800-1900
Wood
H. 135.2 cm
63.283

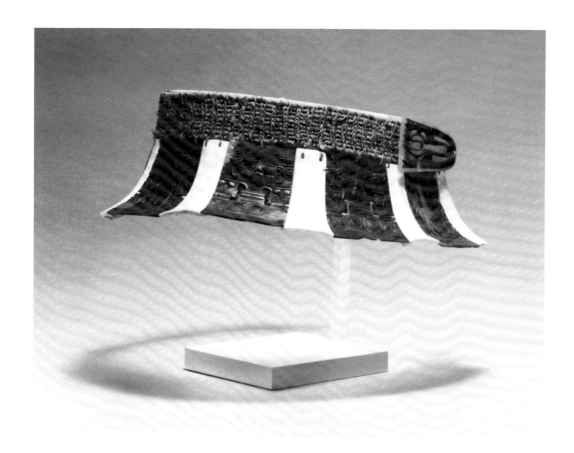

86
Coronet, *paekaha*
Marquesas Islands
Turtleshell, tridacna shell, fiber
H. 8 cm
Evan F. Lilly Memorial
69.123

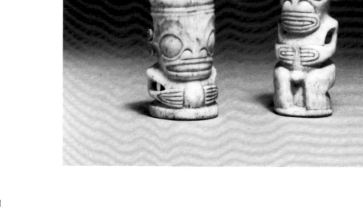

87 and 88
Ornaments, *ivi po'o*
Marquesas Islands
Bone
Left, H. 4.9 cm
Raymond and Laura Wielgus Collection, 79.79.1
Right, H. 6.2 cm
72.99.2

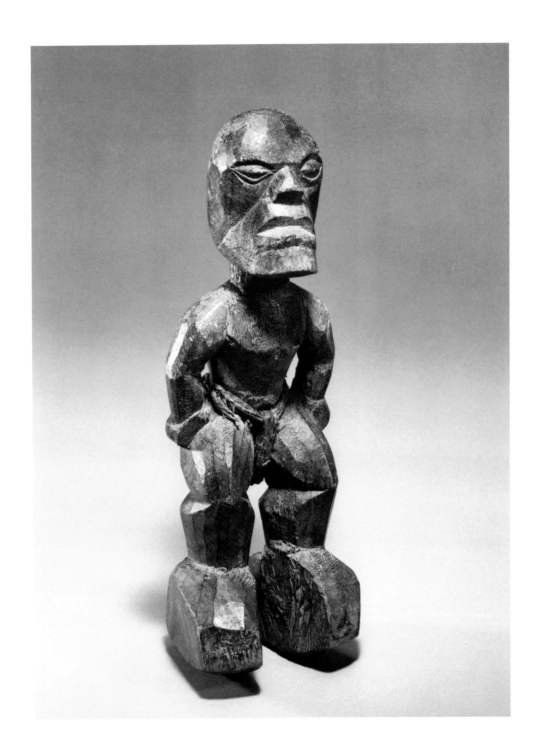

89
Figure, *aumakua ki'i*
Kona district, Hawaii
1800-1825
Wood, fiber
H. 40.6 cm
82.41
Former collection of James Hooper

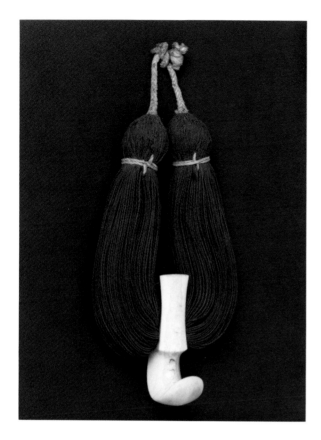

90
Pendant Necklace, *lei niho palaoa*
Hawaii
ca. 1800-1900
Ivory, braided hair, fiber
L. 35.1 cm
80.23
Former collection of Frederick R. Pleasants

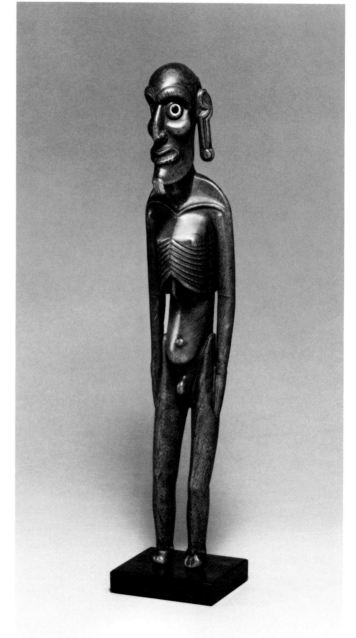

91
Figure, *moai-kavakava*
Easter Island
Wood, obsidian, haliotis shell
H. 38.3 cm
Raymond and Laura Wielgus Collection
80.5.1

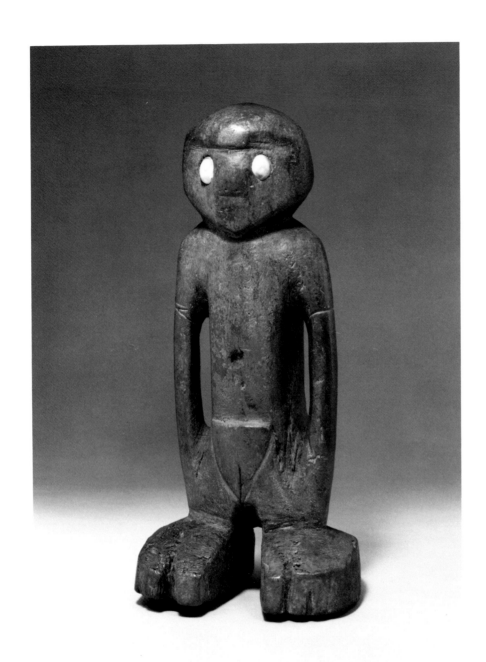

92
Figure
Tuvalu (Ellice Islands)
Wood, shell
H. 38 cm
Raymond and Laura Wielgus Collection
68.214

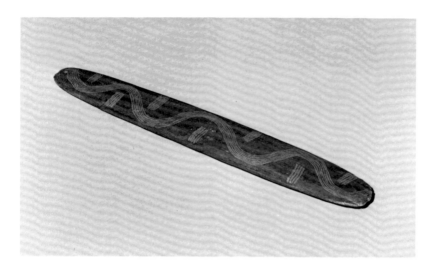

93
Bull Roarer
Australia
probably Central
Desert area
Wood
L. 33 cm
63.116

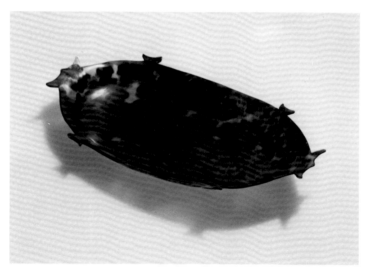

94
Currency Object
Palau Islands
Turtleshell
L. 20.5 cm
Gift of Ernst and Ruth Anspach
77.68.2

95
Sacred Board, *tjuringa*
Western Australia
Wood, pigment
L. 160.6
80.2.2

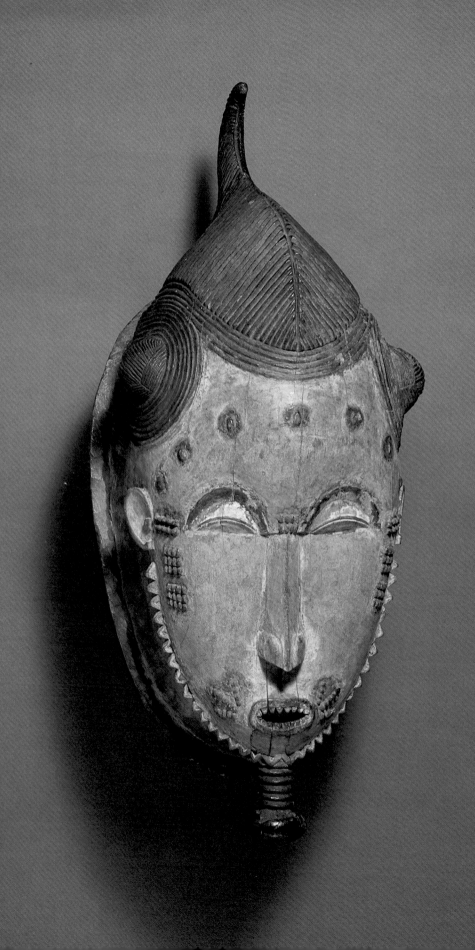

African Arts

Roy Sieber

The cultures of the subcontinent of Africa south of the Sahara have given rise to artistic traditions that have been acknowledged only within the past half century as major contributions to the arts of the world; even more recently have they begun to find a place in major art museums. The arts of Africa came to the attention of the West in the early years of the twentieth century when artists in France and Germany found them worthy of esteem. Their admiration was for the forms of the works, and, except in the most general terms, they knew little and cared less for the meaning of the arts in the cultures that had given rise to them. Until World War II, collectors continued to approach African sculpture as an aesthetic adventure, but thereafter they developed a concern for the cultural context that had originally supported the works. The emphasis of researchers in recent years has been on the use and meaning of the arts in their original setting.

The climate of Africa ranges from the desert regions of the Sahara in the north and the Kalahari in the south to dense equatorial forests, as well as to areas of savannah and open forest. All regions, excepting the deserts, support herding and/or agriculture. Nearly all major African sculpture was produced by settled societies engaged in subsistence agriculture. These sedentary cultures are to be found from south of the Sahara, through the savannah and the open orchard bush of the western Sudan, to the coastal forests of the Guinea Coast that continue as the equatorial forests of central Africa, and on to the savannah of southern Zaire and Angola.

Nomadic and semi-nomadic peoples are to be found in the southern Sahara. Others are the cattle keepers of eastern and southern Africa, and the hunter-gatherers such as the pygmies of central Africa and the San bushmen of southern Africa.

Mask, *goli kpan*
Akan-Baule; Ivory Coast
Wood, pigment
H. 50.4 cm
77.34.1
Illustrated in H. Clouzot, Sculptures Africaines et Oceaniennes,
[1923?]; former collection of Frederick R. Pleasants

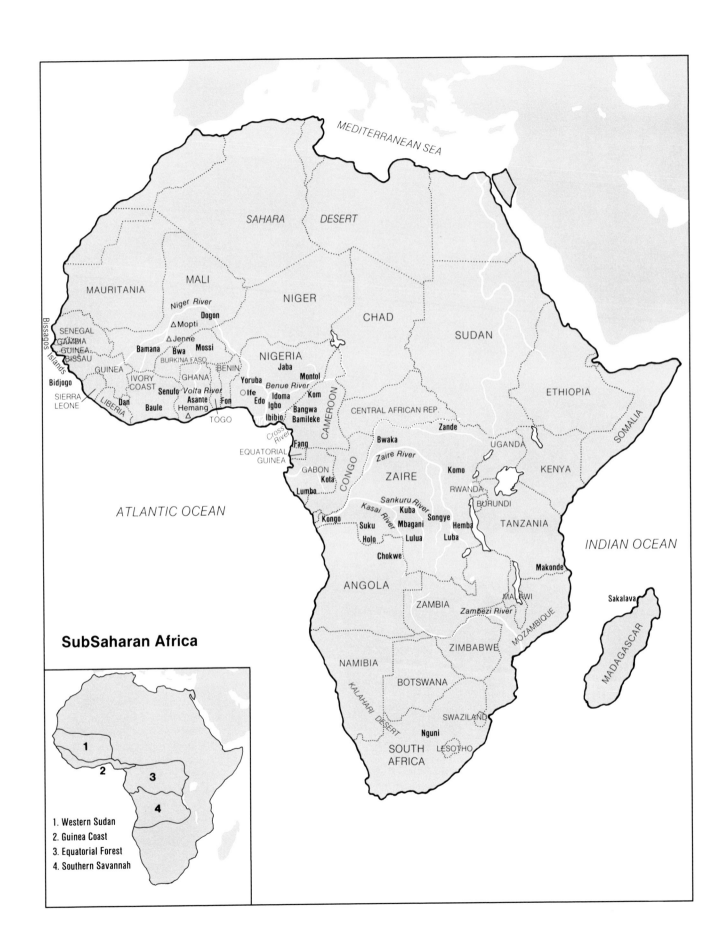

MEDITERRANEAN SEA

SAHARA DESERT

MAURITANIA

MALI

NIGER

CHAD

SUDAN

Niger River

Dogon
△Mopti

SENEGAL
GAMBIA
GUINEA
BISSAU

Bamana △Jenne
Bwa Mossi

BURKINA FASO

NIGERIA

Jaba

Bissagos Islands

GUINEA

IVORY
COAST

GHANA Volta River

BENIN

Yoruba
○Ife
Edo

Montol

Benue River
Idoma Kom

ETHIOPIA

Bidjogo

SIERRA
LEONE Dan

LIBERIA Baule

Senufo

Asante
Hemang
△

Fon Igbo

Ibibio

Bangwa
Bamileke

CENTRAL AFRICAN REP.

SOMALIA

TOGO

Cross
River

Zande

EQUATORIAL
GUINEA

Fang

Bwaka

Zaire River

Komo

UGANDA

KENYA

GABON Kota

CONGO ZAIRE

RWANDA

Lumbo

Sankuru River

BURUNDI

Kasai River Kuba Songye

ATLANTIC OCEAN Kongo

Suku Mbagani Hemba

TANZANIA

Holo Lulua Luba

INDIAN OCEAN

Chokwe

Makonde

Sakalava

ANGOLA

MALAWI

Zambezi River

MADAGASCAR

ZAMBIA

SubSaharan Africa

ZIMBABWE

MOZAMBIQUE

NAMIBIA

BOTSWANA

KALAHARI DESERT

SWAZILAND

Nguni

SOUTH
AFRICA LESOTHO

1

2

3

4

1. Western Sudan
2. Guinea Coast
3. Equatorial Forest
4. Southern Savannah

Unfortunately, little is known of the history of African art. If it is possible to project backwards from recent arts, much must have been made in perishable materials, predominantly wood. Such fragile art forms did not survive the climate and the insects, and thus no record of them exists. Only arts in imperishable materials such as fired clay (terra cotta) and the copper-based alloys, bronze and brass, have survived to give some indication of the historical arts.

For example, terra cotta images from Mali have been dated from the thirteenth to seventeenth centuries. Two broad styles exist. One from the neighborhood of Jenne is represented by a fine equestrian figure (no. 96). Jenne works would seem to be stylistically related to early Dogon figures called Tellem. From southwest of Jenne a more elongated style is termed Bankoni (no. 97). Stylistically, it may be ancestral to the objects in wood that have been produced more recently by the Bamana. These are among the rare instances where an historical sequence of styles can be reconstructed.

Another figurative terra cotta tradition existed in northern Nigeria. The Nok culture is much earlier than that found in Mali, dating from the late first millenium B.C. Other traditions are from Ife in western Nigeria, dating shortly after the first millenium A.D., and from the Akan of Ghana, which date from the seventeenth to the twentieth centuries. A fine Akan example in the collection comes from Hemang and probably dates from the eighteenth century (no. 114).

The earliest known copper alloy castings in West Africa come from Igbo Ukwu in eastern Nigeria and date about A.D. 1000. Remarkably naturalistic bronzes from Ife date a few centuries later. These preceded and possibly influenced the famous bronze castings from Benin. The commemorative head of an *Oba* (king) in the collection once graced an altar in the royal palace in the city of Benin (no. 120). It has been attributed to the middle period of Benin art history and tentatively dated to the seventeenth or eighteenth century.

As noted, wood does not survive long in Africa. Therefore, most of the wooden works of African art were probably produced only a generation or two before they were collected and removed. Thus, with few exceptions, wooden objects are at the oldest from the nineteenth century and many—perhaps most—were made in the twentieth century. Although relatively young, many show a patination that indicates the manner in which they were used. Some were handled and achieved a polish; others had libations of palm wine or blood poured over them and acquired a crusty surface. Masks may have been repainted for each appearance and exhibit several layers of paint. In short, each object carries evidence of its own history.

It must be stressed that for most Africans the objects discussed here have become superannuated; not simply outdated like last year's automobiles or fashions in clothing, but rather conceptually out-distanced, culturally out-worn like the horse and buggy. It is true that there are some places in subSaharan Africa where the old forms survive, but they have been modified by the massive changes in education, transportation, agriculture, medicine, and government. In short, modernisms are to be felt, as no doubt they should be, even in areas of entrenched conservatism. As a result, the only places where one can be certain to find artistic traditions preserved are in museums and private collections in and outside Africa.

Yet every example, every work of art that survives in such protected contexts has had its normal life cycle interrupted. The objects, without exception, were made, and often made brilliantly well, to be used until they were used up, lost to insects or fire or destroyed by the climate. And then they were replaced. The individual work of art was an object that occupied for the moment a cultural niche which had been previously occupied and would again be occupied by comparable pieces. But those objects were not necessarily identical; for Africans, supremely realistic, were able to distinguish between the useful, the beautifully useful, the useful-with-impact. Tied to traditions of form and style and wedded to patterns of specific use and meaning, change and invention were nevertheless recognized and, within reason, were accepted and rewarded.

In the West, in a time of instant aestheticism and constant change, of objects made for a minority and enshrined in museums, the aspects of traditional African art that are easiest to miss are its conservatism and its usefulness in its original setting. Made to reinforce entrenched values, rarely critical of its parent society, African art, unlike modern Western art, springs from a sense of fixed and relatively unwavering beliefs shared by the larger culture. It is exactly this, then, that characterizes traditional African art objects: they are works

made by Africans of a particular cultural entity for their own use, and used as devices to reinforce, illustrate, illuminate, represent, or symbolize the core of values of the culture at large or some significant segment of it.

It is, therefore, not surprising to discover that the arts, and particularly the art of sculpture, depict broadly shared human values; they become a commentary on the human condition. Thus sculptures that deal with basic human experiences such as birth (no. 116) and death (no. 98), the security of the individual and of the group, are to be found in many African societies. In this, African art is like much of the art of the history of the world, but, at the same time, it is unlike much recent art in the West. As such it intersects and reinforces the positive aspects of a culture's religious beliefs.

One of the basic aspects of African culture that involves the arts is the concept of coming-of-age. In nearly all societies, both girls and boys are prepared for adult life and responsibilities by special ceremonies that are educational as well as ceremonial. Body art and sculptures are often found in conjunction with these activities. In eastern Ghana, for example, girls are taught proper adult behavior through songs, they learn dances, and they are ornamented, over a period of months, with the family's wealth of beads. Finally there is a coming-out ceremony when they perform the dances, sing the songs, and display their finery, thus declaring their fitness for adult life and its responsibilities (fig. 1).

In southern Zaire a group of cultures share the term, *mukanda,* for the coming-of-age ceremonies for boys and young men. In each, masks appear, some worn by the initiated older men and, in several instances, by the initiates themselves. Some of the most impressive sculpture from this region takes the form of the masks of the initiation camp (no. 149).

However, with all masking traditions, the mask—the portion we celebrate in our collections and museums—is only a small part of the costume and the ritual in which it appears. Never seen in isolation and always in motion, the masks are associated with dance, music, and song texts and the beliefs and myths of the group. A masked figure may come to a village to demand food for the initiates; ritually a mask may help secure the success of agriculture (fig. 2; no. 101), appear at funerals (fig. 3), secure the fertility of the women, avert evil forces, celebrate an ancestor, or offer entertainment in a secular context (no. 103). In short, masks may be associated with nearly all aspects of life.

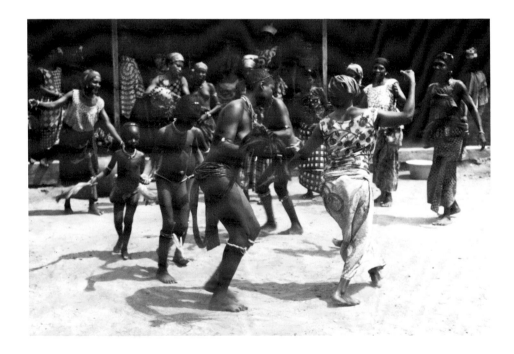

Fig. 1
Ga girls in a coming-of-age
ceremony, Ghana, 1967
Photo courtesy Roy Sieber

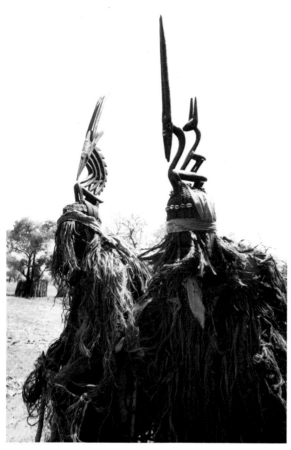

Fig. 2
Bamana *chi wara* performers, Mali
Photo courtesy Eliot Elisofon Archives
National Museum of African Art

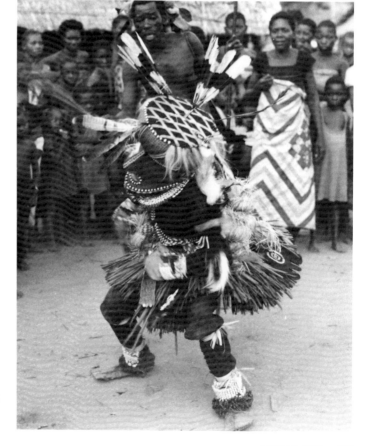

Fig. 3
Bwoom masquerade performance at a Kuba funeral, Zaire, 1981
Photo courtesy David A. Binkley

Like masks, figurative sculptures are dedicated to the well-being of the group. The specifics may vary from culture to culture, but, again, in the larger sense the sculptures may be said to reflect those beliefs that affect the security of the people who use them. Their uses range from personal protection (no. 124) to health (no. 128) and group protection (no. 146), from maternity (no. 152) to ancestors (nos. 98 and 134).

Figures tend to be symmetrical, frontal. The head is emphasized, resulting in a ratio of head to body of 1:3 or 1:4. Torsos are usually long, but legs are short and often bent at the knee; arms are bent and parallel the torso; hands, at times oversized, often touch the hips or the navel. At the same time, details are accurately depicted, with hair arrangements and scarification precisely delineated. The overall effect is one of hierarchy, austerity, even remoteness, which is emphasized by the withdrawn, expressionless character of the faces. Types include standing, seated, kneeling, and equestrian figures.

Several mask types exist. Simple face masks (color plate, p. 98) and hood or casque masks (no. 153) are found throughout the sculpture-producing areas. Horizontal masks (no. 102), yokes (no. 103), and crests or headdresses (no. 100) occur mostly in West Africa, in the western Sudan and Guinea Coast. Masks are at times simply blackened (no. 108), at times highly colored (no. 127); red, black, and white predominate.

The artists that produced these works were, for the most part, well known to their clientele. Usually they mastered their craft and developed a command of their tools and media through apprenticing to a master, often a parent or relative. Whether they were potters (women's specialization), ironworkers or woodcarvers (men's work), or weavers (men and women, but using different loom types), there were among them brilliant artists whose works rise above the run-of-the-mill products of average artisans. And they were recognized as outstanding by their audience. Clients might travel for miles to commission a work from a particular artist.

For the most part the sculptor worked only on commission, to satisfy the demands of his patrons. He did not create works and then search for a client; art dealers were unknown. The artist was a part-time specialist in most African cultures. He was, like other members of the society, first and foremost a farmer responsible for the well-being of his family. At times he was a functioning and respected member of society, at times he was outside the social mainstream. An example of the latter is the Bamana blacksmith who was also a sculptor and whose wife was a potter. They were not part of the agricultural core group. They did not intermarry even though the blacksmith played an important ritual role in Bamana culture.

African sculpture may be divided stylistically in several ways. First, there is the so-called tribal style, that is, the style of a core group defined by language and cultural traits. A pioneer historian of African art, Carl Kjersmeier, in the 1930s published several volumes dividing African sculpture into tribal style units. As a scheme for dealing with masses of stylistically distinct carvings, it remains a most convenient categorization despite some problems, both political and art historical. Politically, the term "tribe" offends many contemporary Africans, because it refers to a division that contradicts the growing sense of nationalism, for most countries consist of several, or many "tribes." Art historically, the concept of tribal style ignores historical developments to focus on the "ethnographic present," the sense that the tribe was historically and stylistically static, and that ideal time is the moment of European contact. Anthropologists have disavowed this simplistic approach, but it continues to color our view of the history of art in Africa.

Further, art historians have discerned style areas larger and smaller than the "tribe." Areas that involve strong stylistic similarities exist, for example, in the western Sudan, the Guinea Coast, the equatorial forest, and the southern savannah of southern Zaire and northern Angola.

In some cases linguistic divisions seem useful. Thus, for example, the Mande-speaking groups of the western Sudan share historical and stylistic traits that argue that language can serve as a useful approach to cultural and artistic affinities. Similarly, smaller units exist. Among the Yoruba, for example, sub-tribal styles, village and family styles, are identifiable. Finally, in Africa as, indeed, anywhere in the world, it is possible to identify the styles of individual artists and workshops.

Unfortunately, for much of the latter sort of refinement of stylistic analysis few data exist. Early collectors may have identified a tribe or even a village, but they neglected to ask the name of the individual artist or his

family. In the past twenty-five years, researchers have been asking such questions, and our knowledge of individual artists is improving, but much earlier data are forever lost. It is possible, with some confidence, to recognize individual hands in some instances. Only our ignorance of the artist's name has allowed us, falsely, to presume that the art was anonymous in the culture of origin.

Thus far the emphasis of this essay has been on sculpture. There are for Africa as for elsewhere a large number of art forms and materials. The only medium common to the West that is all but absent in Africa is painting. No easel painting existed before its recent introduction from Europe. In addition to rock art in the Sahara and in southern Africa, mostly of prehistoric date, there was a certain amount of mural painting in earth colors on the mud walls of houses and shrines, which was primarily the work of women. Like mud sculpture, it was too fragile to travel and exists only in photographic records (fig. 4).

Architectural forms are more elaborate for settled villages and are of several basic types: among them are round huts of mud or wattle and daub with conical thatched roofs, and rectangular structures with pitched thatch or flat mud roofs. Nomadic and hunter-gatherer societies tend to use transportable types, such as tents, or easily constructed and less permanent forms.

All over Africa portable objects for everyday use were handmade. Among these, jewelry, textiles, furniture, and containers are worth particular notice as art objects. Some are developed into works that enhance and reflect the status of the wearer or user. Jewelry and ornaments of cast bronze or imported beads or shells are represented in the collection (no. 109); the former are mostly from West Africa. The use of beads and shells is ubiquitous; beaded ornaments from southern Africa and a group associated with leadership among the Kuba of Zaire are noteworthy. Similarly, spectacular cloths are woven and/or ornamented, as, for example, the Kente cloths of the Asante of Ghana woven of cotton or silk on

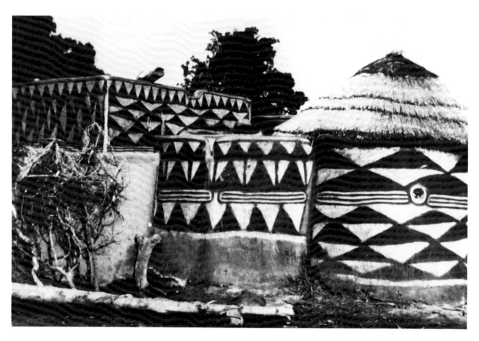

Fig. 4
Frafra compound
Northern Ghana, 1973
Photo courtesy Fred T. Smith

horizontal strip looms by men and decorated with complex woven weft patterns (no. 115), or the Kuba cloths of raffia woven by men and decorated by women with embroidery and appliqué (fig. 5; nos. 156, 157, and *detail,* cover). The Kuba also produced delicately decorated cosmetic boxes (no. 154) and elaborate, often sculptural, drinking cups (no. 155). The Yoruba of Nigeria made richly carved ivory boxes; particularly fine ones were made in the city of Owo (no. 118).

Materials vary considerably. Wood carved from a single piece is the most often used medium for sculpture, with, at times, applied metal, cloth, or beads as among the Songye (no. 161) or Kota (no. 134). However, sculptures of cast metal and ivory are also to be found. The Kingdom of Benin is especially well known for its cast bronze (actually a copper-based alloy either bronze or brass), as with the fine middle period commemorative head of an *Oba* from the palace at Benin City (no. 120).

Iron was smelted and forged in the production of tools and weapons. Different groups produced characteristic variations on a number of basic knife forms. However, ritual objects were also made of iron, as for example the Fon *asen* shrine object (from the Republic of Benin, formerly Dahomey; no. 117).

In this brief view of African arts we have tried to emphasize the range of materials, the inventiveness of forms, and the variety of uses of traditional African works of art. Ritual objects were imbued with deep, strongly shared beliefs. Whether working for kings or commoners, the artists were known and highly regarded for their skill and for the objects they produced, and they were respected for the role they played in the society. From the objects that survive in our museums, we can sense, to some extent, echoes of the importance of the objects in traditional life. Their aesthetic brilliance and strength of form communicate the artistry of their makers and the depth of the cultures that gave rise to them.

Fig. 5
Kuba woman wearing ceremonial skirt, *ncaka nsueha,* Zaire, 1981
Photo courtesy Patricia Darish

Suggestions for Further Reading

Bascom, William. *African Art in Cultural Perspective*. New York, 1973.

Delange, Jacqueline. *The Art and Peoples of Black Africa*. New York, 1974.

Eyo, Ekpo and Frank Willett. *Treasures of Ancient Nigeria*. New York, 1980.

O'Meara, Patrick and Phyllis Martin. *Africa*. Bloomington, In., 1977.

Sieber, Roy. *African Furniture and Household Objects*. New York and Bloomington, In., 1980.

Willett, Frank. *African Art*. New York, 1985.

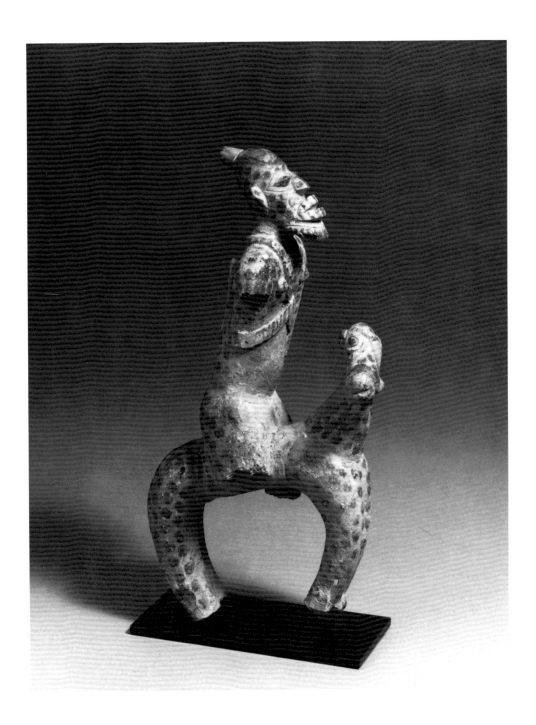

96
Equestrian Figure
Jenne culture; Inland Niger Delta, Mali
A.D. 1645 +/- 165 (thermoluminescent dating)
Clay, pigment
H. 24.4 cm
76.98.1

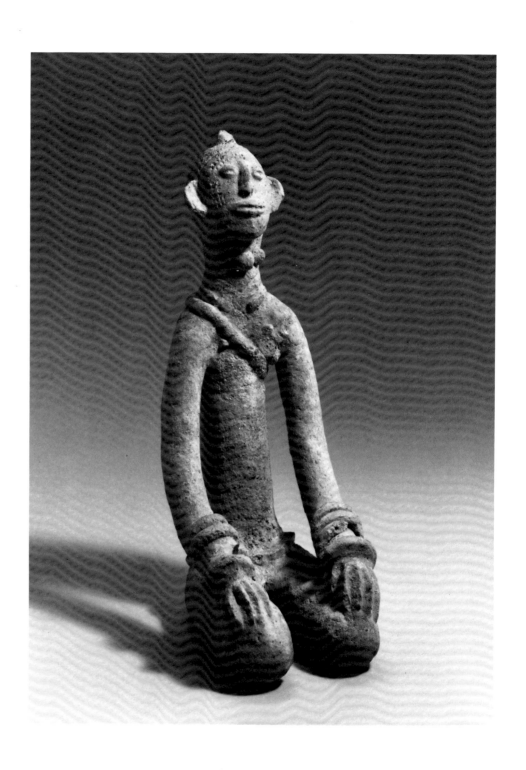

97
Figure
Bankoni style; Inland Niger Delta, Mali
A.D. 1379 +/− 100 (thermoluminescent dating)
Clay
H. 42.2 cm
82.12

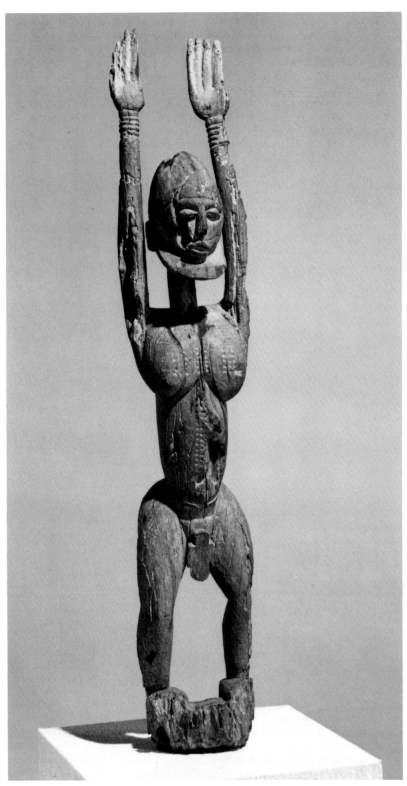

98
Figure
Dogon; Mali
Wood
H. 115.6 cm
Raymond and Laura Wielgus Collection
100.27.5.79

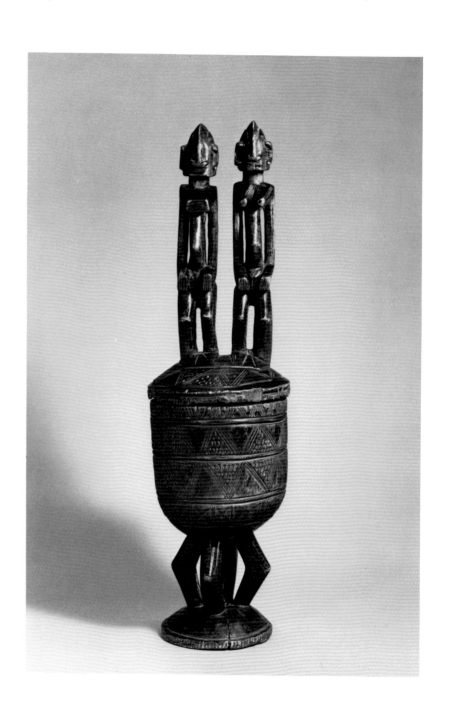

99
Lidded Bowl
Dogon; Mali
Wood
H. 83.5 cm
63.213

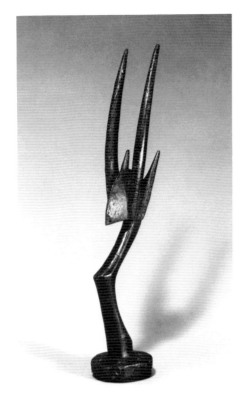

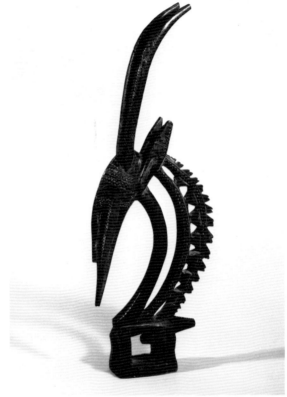

100
Headaddress, *chi wara*
Bamana; Mali
Wood
H. 53 cm
Raymond and Laura Wielgus Collection
100.3.5.79

101
Headaddress, *chi wara*
Bamana; Mali
Wood
H. 91.4 cm
Gift of Frederick Stafford
60.10

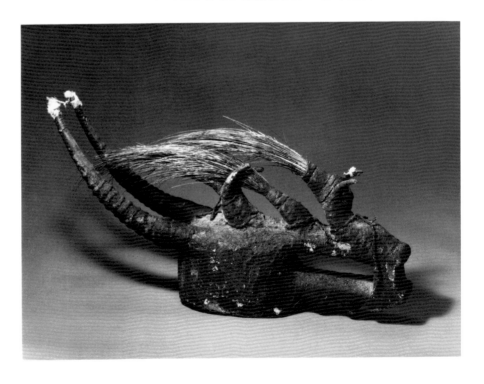

102
Mask, *komo*
Bamana; Mali
Wood, resin, feathers, quills, fiber,
animal hair
L. 68.6 cm
72.111

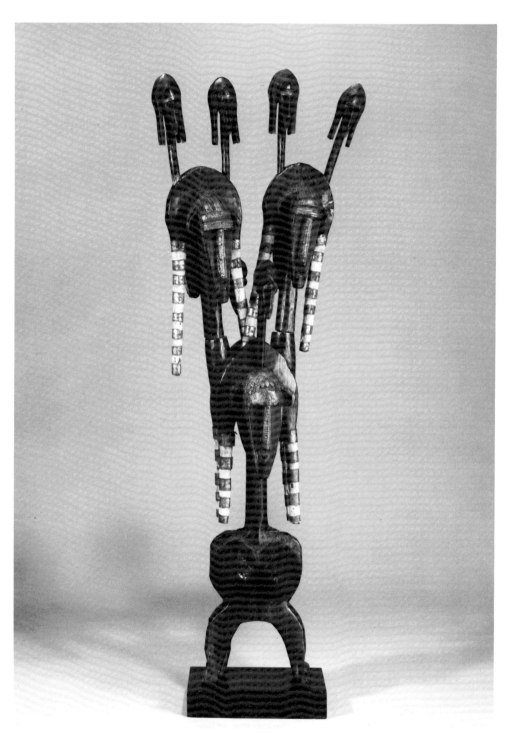

103
Marionette Headdress
Bamana; Mali
Wood, brass, cloth
H. 146.7 cm
77.87
Collected by F.H. Lem
in Siela village near San, 1934-35;
former collection of Helena Rubinstein

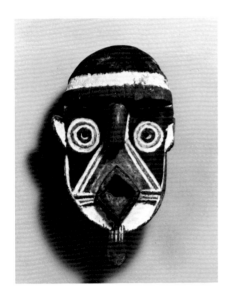

104
Mask
Bwa; Burkina Faso
Wood, pigment
H. 34.3 cm
76.123

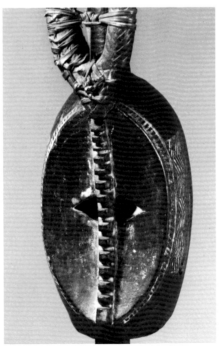

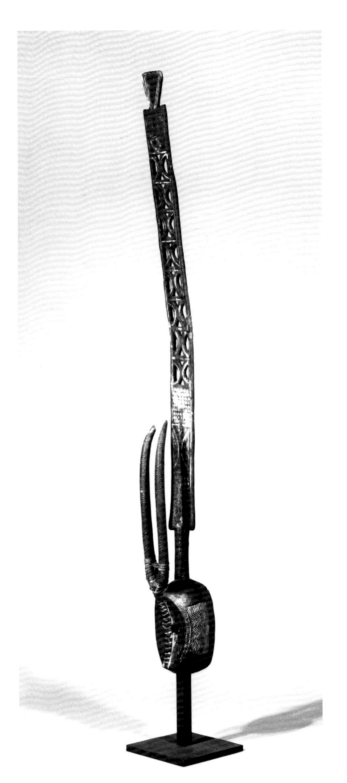

105
Mask, *karanga*
Mossi (Yatenga style); Burkina Faso
Wood, pigment, fiber
H. 177.8 cm
Gift of Rita and John Grunwald
71.111

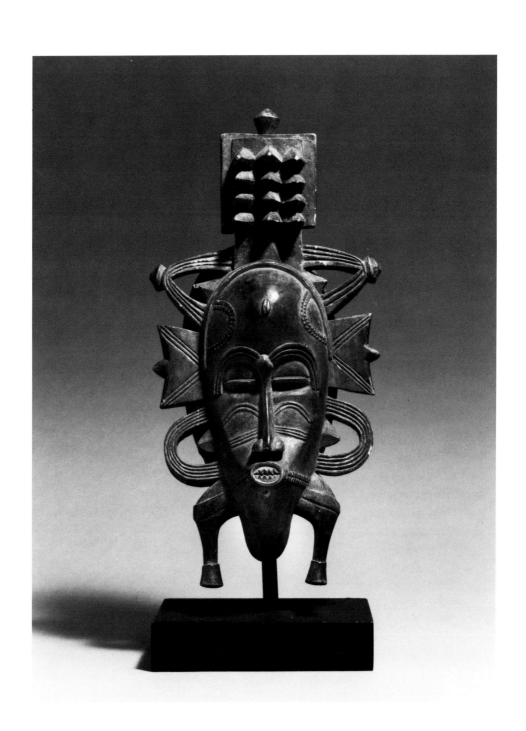

106
Mask, *kpelie*
Senufo; Ivory Coast
Wood
H. 35.6 cm
63.239

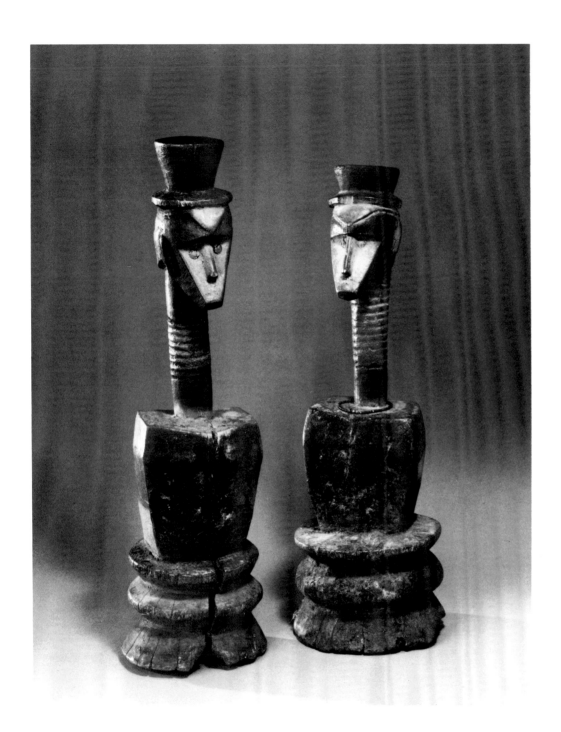

107
Pair of Altar Figures
Bidjogo; Bissagos Islands, Guinea-Bissau
Wood, pigment, iron, beads, fiber
H. 53.3 cm and 50.2 cm
74.55.2; 74.55.1

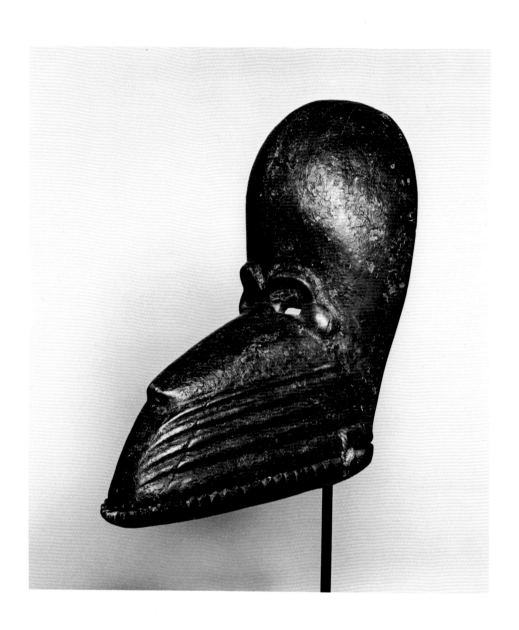

108
Mask
Dan; Liberia/Ivory Coast
Wood
H. 36.2
76.136.2

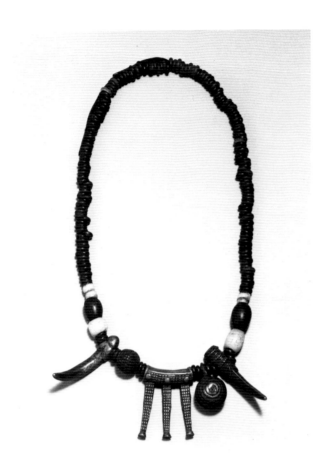

109
Necklace
Dan; Liberia / Ivory Coast
Glass beads, cast bronze, fiber
L. 50 cm
Gift of Ernst and Ruth Anspach
71.44.9

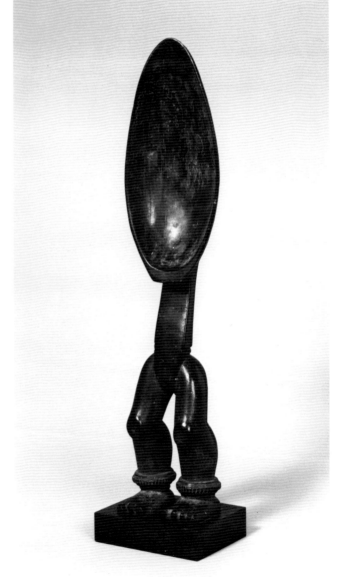

110
Ladle Figure
Dan; Liberia / Ivory Coast
Wood
H. 52.1 cm
63.221

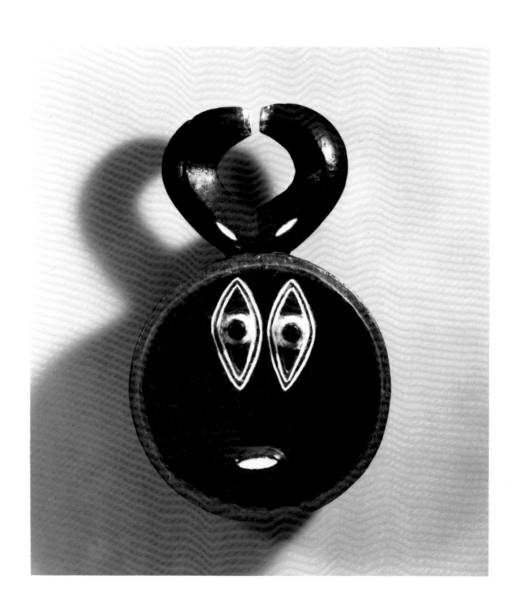

111
Mask, *goli kple kple*
Akan-Baule; Ivory Coast
Wood, pigment
H.43.8
79.71

112
Pendant
Akan-Baule; Ivory Coast
Cast gold
H. 9.8 cm
76.98.2
Former collection of André Derain

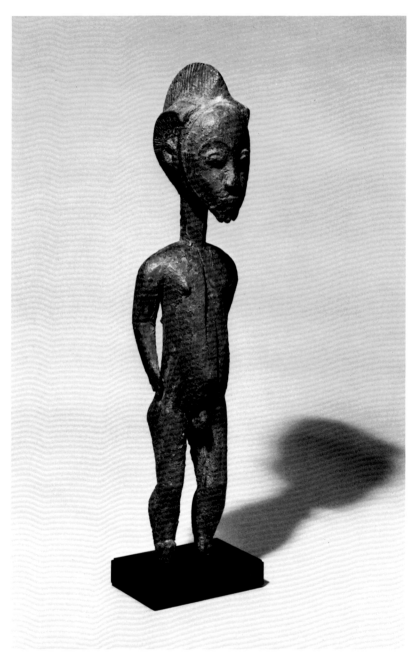

113
Figure
Akan-Baule; Ivory Coast
Wood
H. 44.1 cm
Raymond and Laura Wielgus Collection
100.5.5.79

114
Funerary Head
Akan; Hemang, Ghana
A.D. 1700-1800 (?)
Clay
H. 20.9 cm
85.24

115
Cloth, *kente,* *detail*
Akan-Asante; Ghana
Cotton, silk
320 cm x 208 cm
73.28.5

116
Doll, *akuaba*
Akan-Asante; Ghana
Wood
H. 34.2 cm
72.106.1

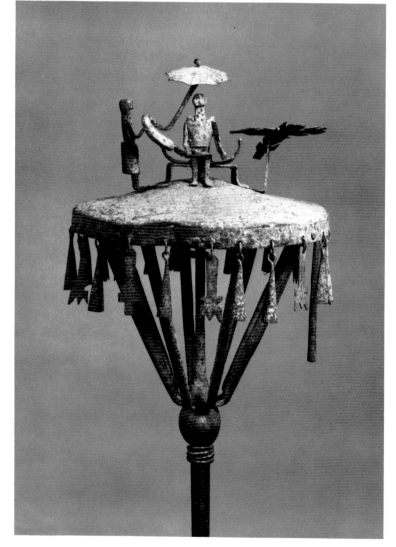

117
Shrine object, *asen,* *detail*
Fon; Widah, Republic of Benin
Iron
H. 168.9 cm overall
Gift of Rita and John Grunwald
74.52

118
Box
Yoruba; Owo, Nigeria
Ivory
L. 16.5 cm
77.28

119
Kola Nut Box in the Form of an Antelope Head
Edo; Nigeria
Wood, brass
L. 34.9 cm
Raymond and Laura Wielgus Collection
75.99.4

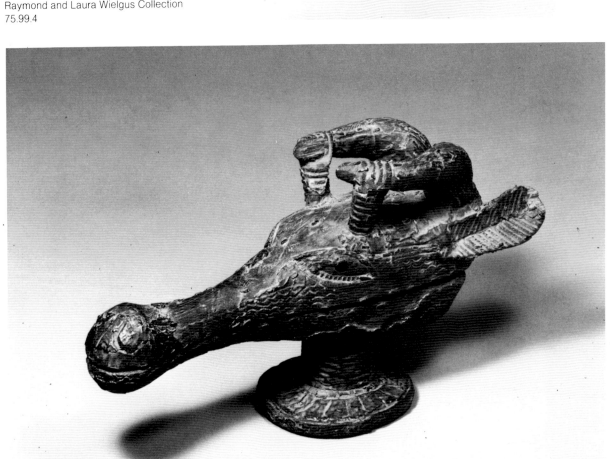

120
Commemorative Head, *uhumnw-elao*
Edo; Court of Benin, Nigeria
Middle period, A.D. 1600-1700
Cast bronze
H. 29.2 cm
75.98
Former collection of William Moore

121
Divination Cup, *agere ifa*
Yoruba; Nigeria
Wood
H. 15.8 cm
77.34.4
Former collection of Frederick R. Pleasants

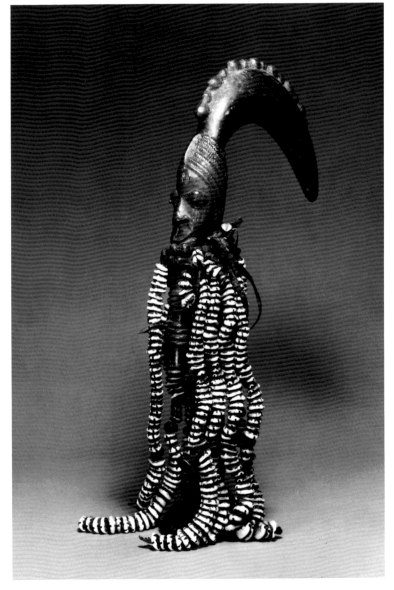

122
Esu/Elegba Staff, *ogo Elegba*
Yoruba; Nigeria
Wood, leather, cowrie shells, brass, bone
H. 50.7 cm
Raymond and Laura Wielgus Collection
100.2.5.79
Collected by Roy Sieber in Oyo in 1958

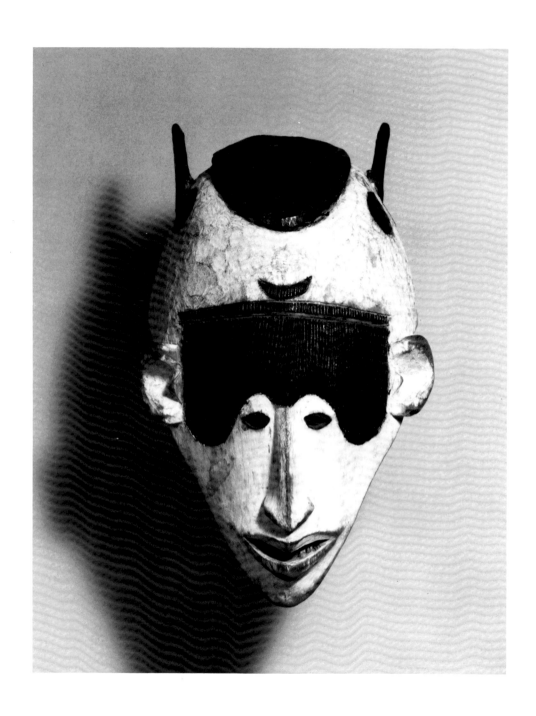

123
Mask, *mmuo*
Igbo; Nigeria
Wood, pigment
H. 30.5 cm
Gift of Frederick Stafford
59.39
Former collection of Museum für Völkerkunde, Hamburg

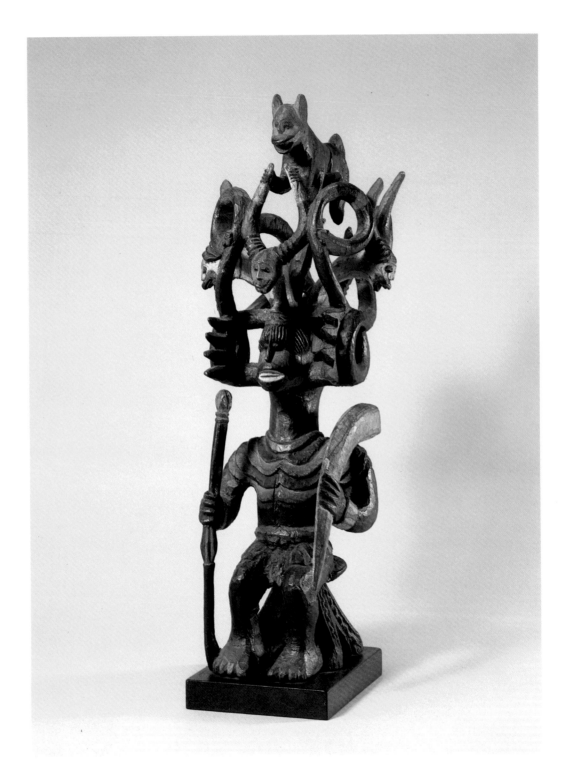

124
Shrine, *ikenga*
Igbo; Anambra Valley, Nigeria
Wood, pigment
H. 61 cm
70.50

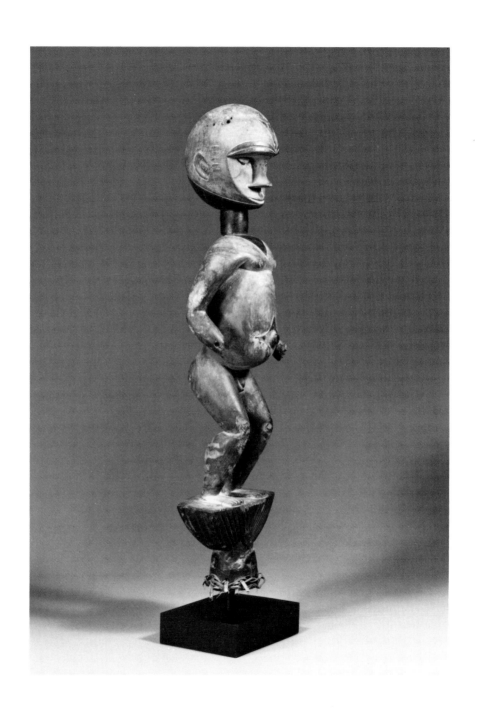

125
Headdress
Ibibio (Eket style); Nigeria
Wood, pigment, fiber
H. 61 cm
76.1.2

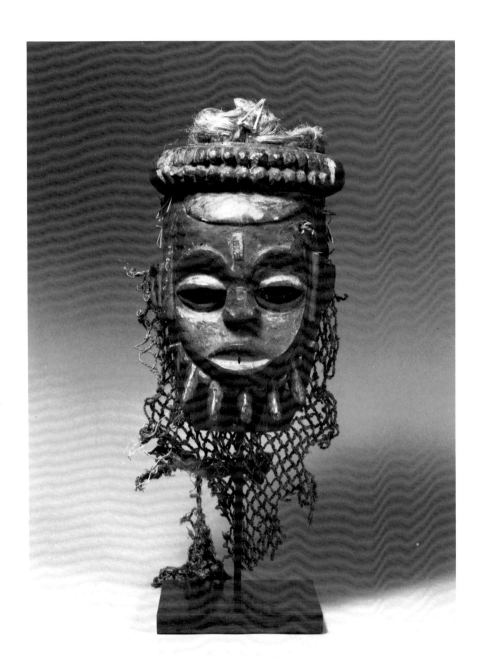

126
Mask
Ibibio; Nigeria
Wood, pigment, fiber
H. 31.9 cm
Raymond and Laura Wielgus Collection
100.6.4.75

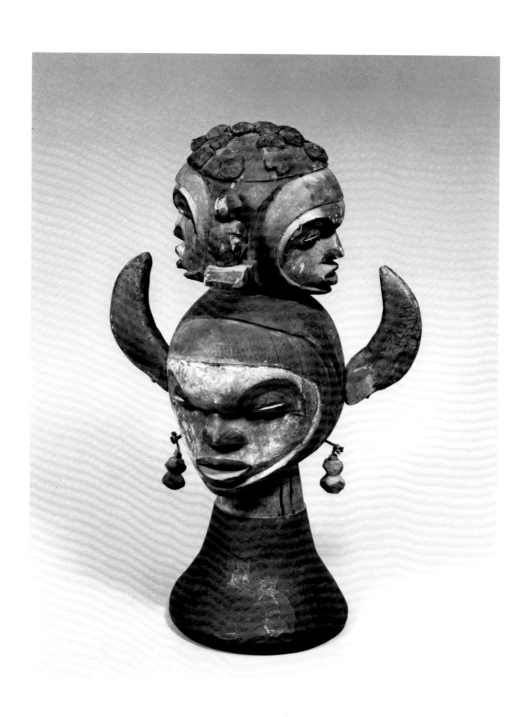

127
Headdress, *ungulali*
Idoma; Nigeria
Wood, pigment, nails
H. 31.8 cm
73.55.1

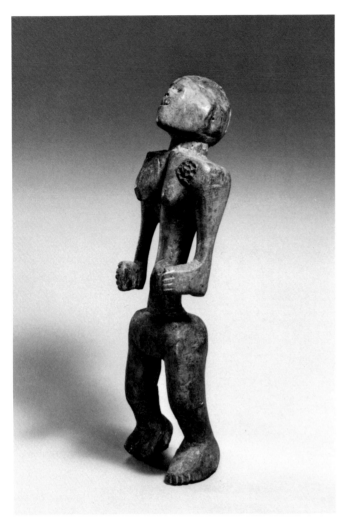

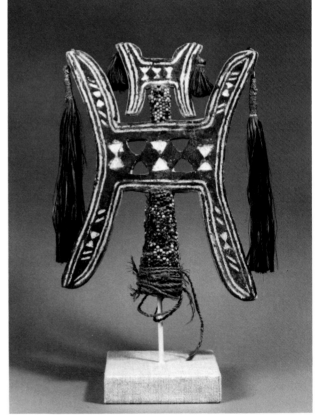

128
Diviner's Figure, Komtin Society
Montol; Nigeria
Wood, pigment
H. 38 cm
Raymond and Laura Wielgus Collection
100.10.5.79
Collected by Roy Sieber in Lalin, 1958

129
Dance Crest, *nyamfaik*
Jaba (Ham); Nigeria
Wood, pigment, seeds, fiber
H. 41.9 cm
Gift of Roy and Sophia Sieber
77.81
Collected by Roy Sieber in 1958

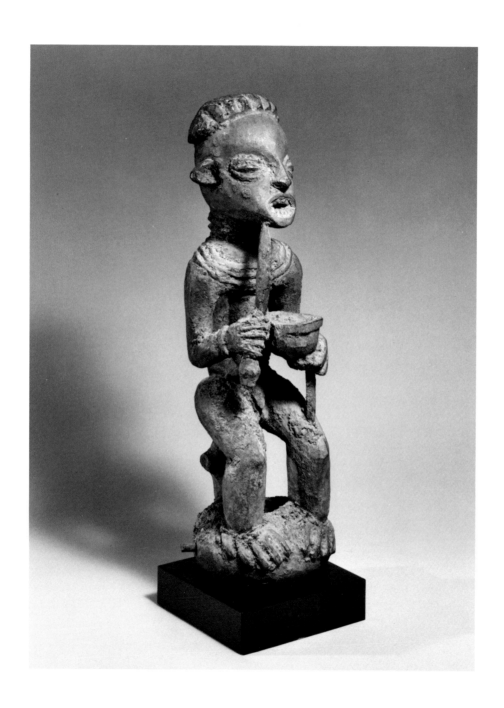

130
Figure, *lefem*
Bangwa; Cameroon
Wood
H. 51.4 cm
Gift in part of Harrison Eiteljorg
and Ernst and Ruth Anspach
82.71

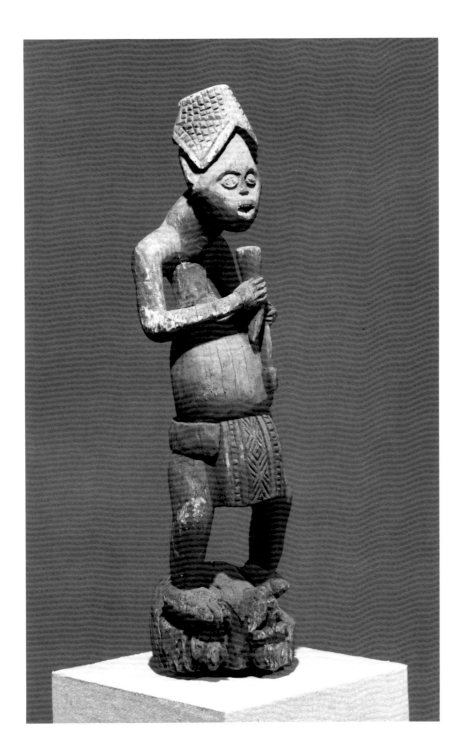

131
Figure
Bamileke; Cameroon
Wood, pigment
H. 102.2 cm
Gift of Rita and John Grunwald
74.32

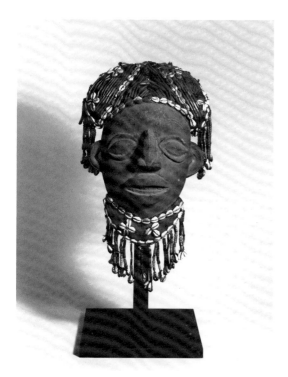

132
Mask
Kom; Cameroon
Wood, glass beads, cowrie shells, fiber, raffia cloth
H. 39.3 cm
68.193
Collected by Gilbert Schneider in Laikom, 1957

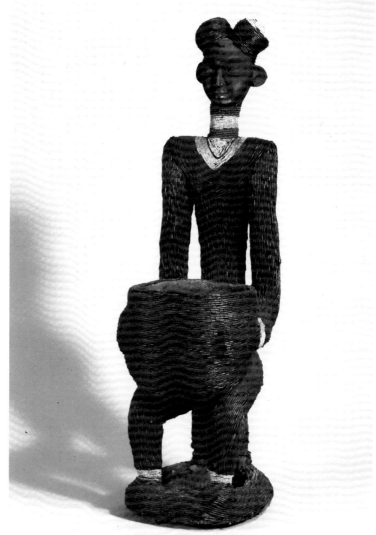

133
Figure
Kom; Cameroon
Wood, glass beads, fiber, iron, raffia cloth
H. 91.4 cm
68.190
Collected by Gilbert Schneider in Laikom, 1957

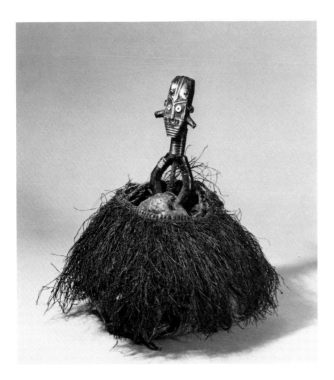

134
Basket with Reliquary Figure
Kota; Gabon
Wood, metal, fiber, primate skull, leaves
H. 36 cm
78.59

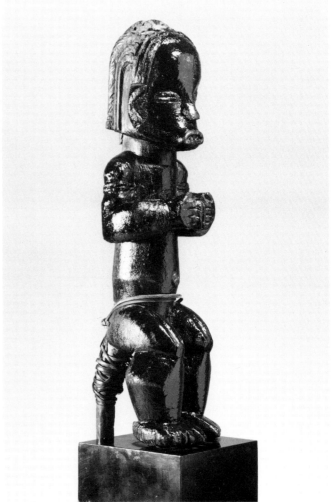

135
Figure, *bieri*
Fang; Gabon
Wood, fiber
H. 43.9 cm
72.141
Former collection of Casa Coray

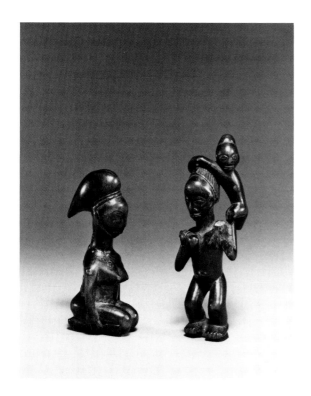

136
Basket Hook in the Form of a Figure
Lumbo; Gabon
Wood
H. 11.1 cm
Raymond and Laura Wielgus Collection
100.7.5.79

137
Spoon Handle
Lumbo; Gabon
Wood
H. 13.6 cm
Raymond and Laura Wielgus Collection
75.99.5

138
Musical Instrument
Lumbo; Gabon
Wood, fiber, pigment
H. 66.6 cm
77.34.3
Former collection of Frederick R. Pleasants

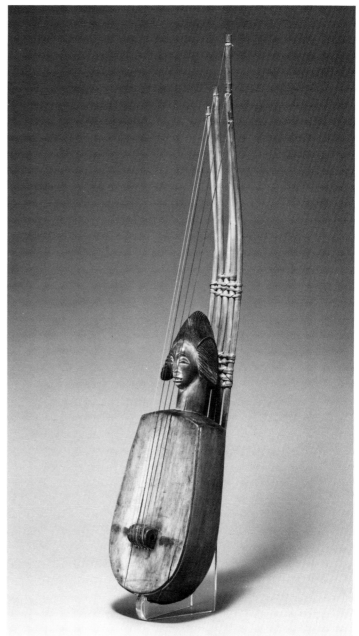

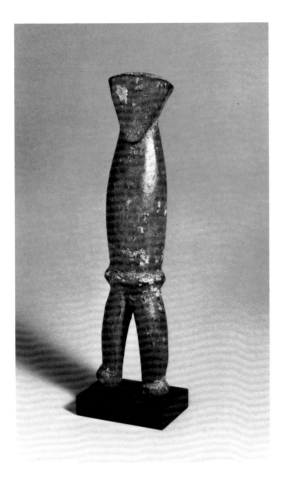

139
Mani Society Figure, *yanda*
Zande; Zaire
Wood
H. 18.4 cm
68.99

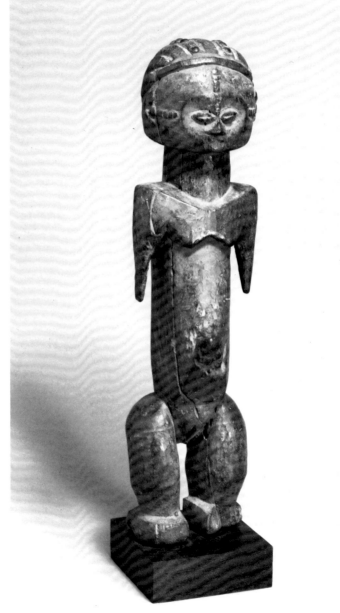

140
Figure
Bwaka; Zaire
Wood, metal
H. 51.1 cm
71.90

141
Headdress
Komo; Zaire
Wood, pigment
H. 49 cm
77.71

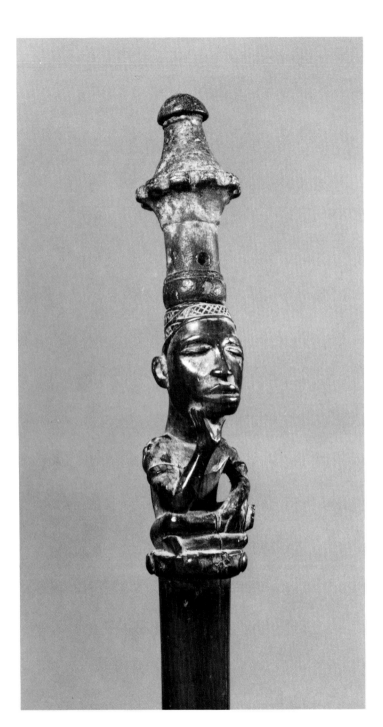

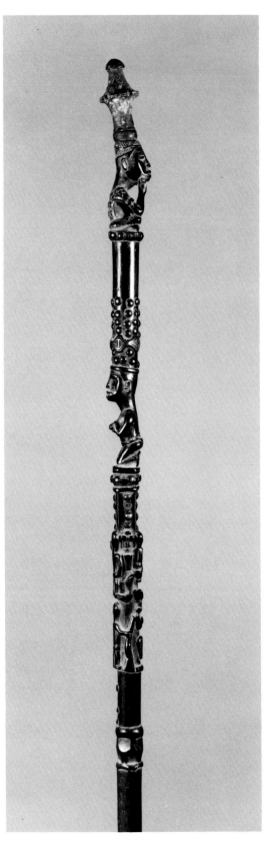

142
Staff, *details*
Kongo; Zaire
Wood, brass nails
H. 121.3 cm
76.1.1

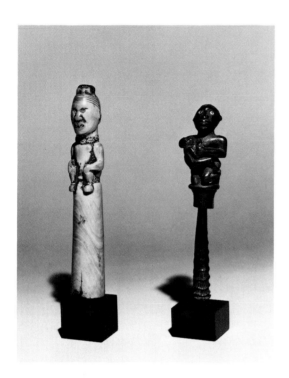

143
Fly Whisk Handle
Kongo; Zaire
Ivory
H. 17.5 cm
76.1.3

144
Whistle
Kongo; Zaire
Wood, horn
H. 15.2 cm
76.136.1

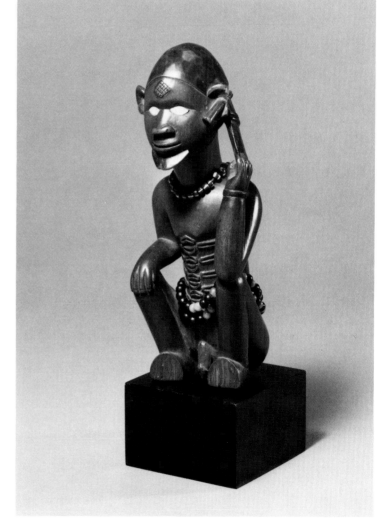

145
Figure
Bembe; Zaire
Wood, shell, beads, fiber
H. 19.1 cm
75.83
*Former collection of the Tara Trust and
Werner and Sally Gillon*

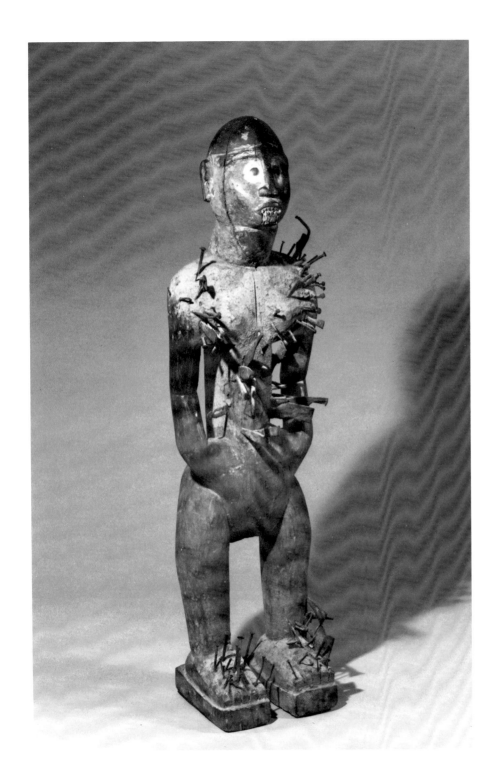

146
Nail Figure, *nkisi n'konde*
Kongo; Zaire
Wood, iron, pigment
H. 102.8 cm
77.29

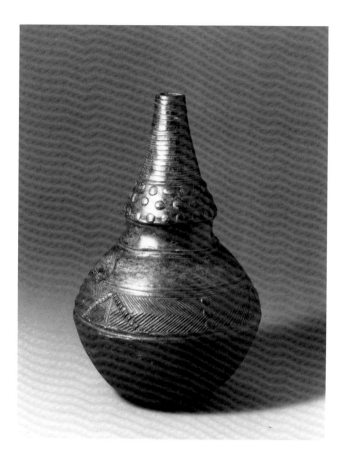

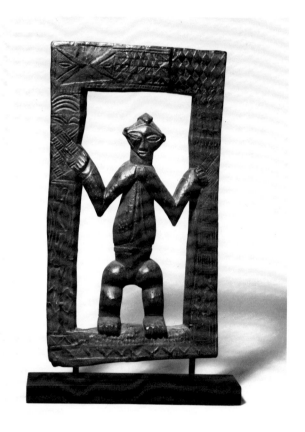

147
Bottle
Kongo; Zaire
Burnished clay
H. 31 cm
63.21

148
Figure, *nzambi*
Holo; Zaire
Wood
H. 31.9 cm
76.136.3

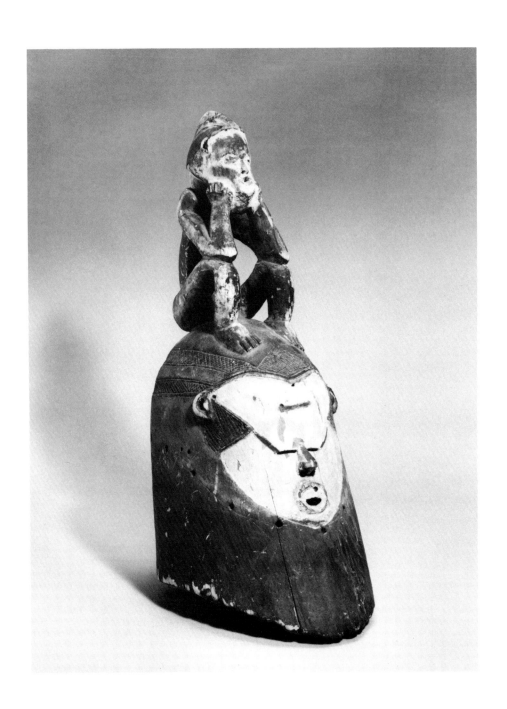

149
Mask
Suku; Zaire
Wood, pigment
H. 50.8 cm
Gift of Mrs. Edward J. Kempf
73.83.12

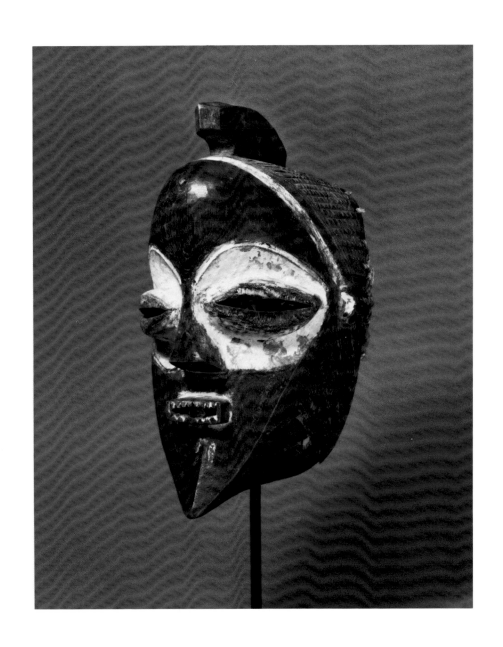

150
Mask
Mbagani; Zaire
Wood, pigment, fiber
H. 35.5 cm
75.54.1

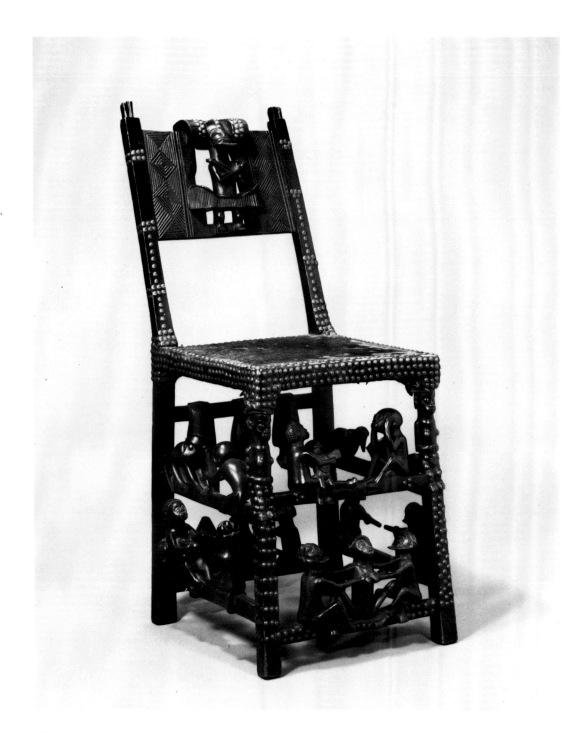

151
Chief's Chair
Chokwe; Angola / Zaire
Wood, antelope hide, brass nails
H. 79.3 cm
76.54

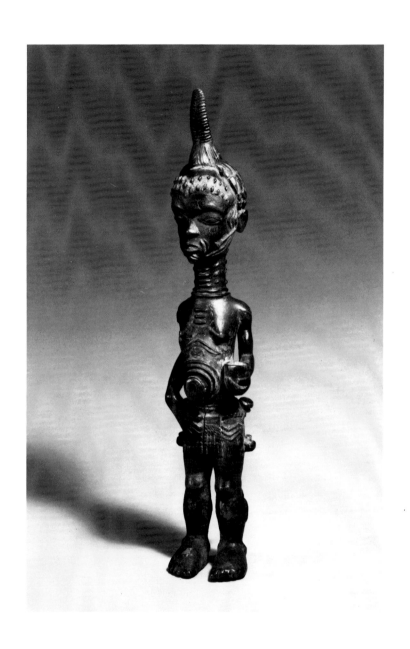

152
Figure, *lupinga lua luimpe*
Lulua; Zaire
Wood
H. 43.2 cm
Raymond and Laura Wielgus Collection
75.91
Collected by Joseph Lassaux in Kananga, Zaire, before 1898

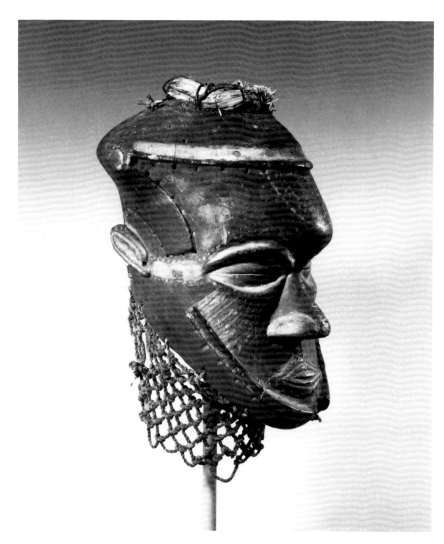

153
Mask, *bongo*
Kuba; Zaire
Wood, fiber, pigment
H. 39.4 cm
63.40

154
Box
Kuba; Zaire
Wood, pigment
L. 29.5 cm
63.216

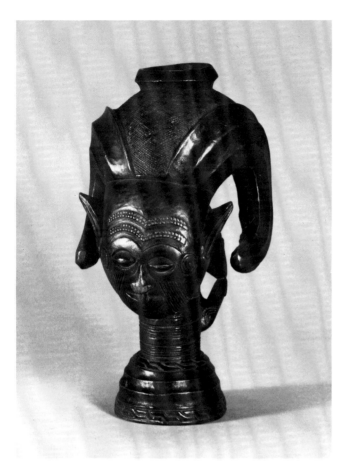

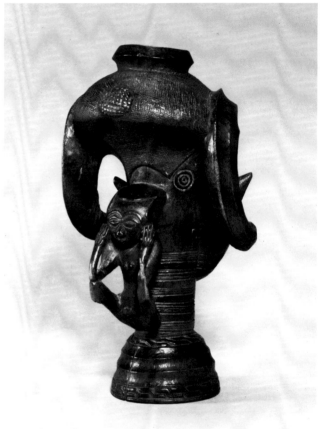

155
Cup
Kuba; Zaire
Wood
H. 27.2 cm
77.34.2
Former collection of Frederick R. Pleasants

156
Woman's Ceremonial Skirt
Kuba (Shoowa ?); Zaire
Raffia plain weave, raffia embroidery and
appliqué, cowrie shells, pigment
L. 474.7 cm
85.23

157
Woman's Ceremonial Skirt
Kuba (Bushoong); Zaire
Raffia plain weave, raffia embroidery
and appliqué
L. 537.8 cm
84.57

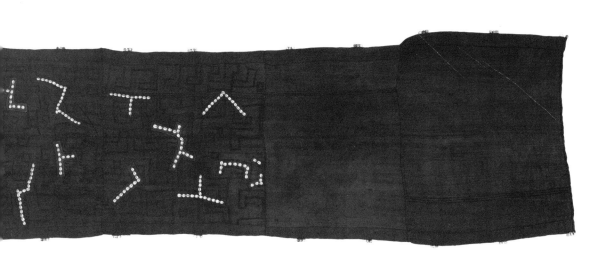

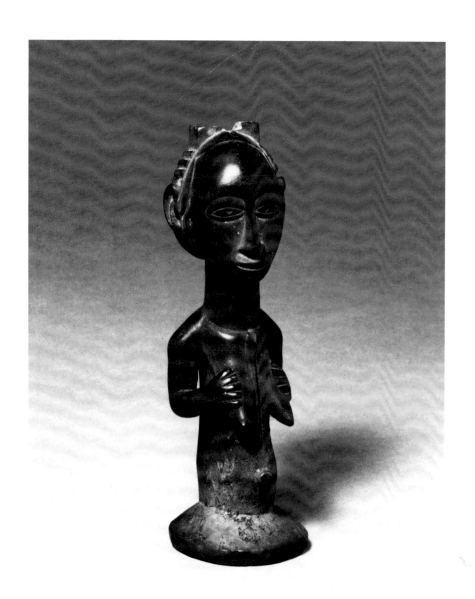

158
Figure, *kakudji*
Hemba (Niembo style); Zaire
Wood, pigment
H. 15.5 cm
71.12

159
Figure
Luba; Zaire
Ivory
H. 9.3 cm
Gift of Frederick Stafford
59.57

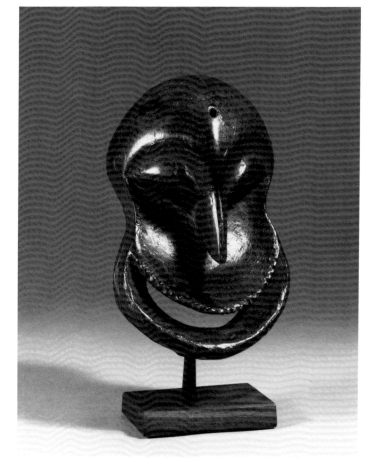

160
Mask, *soko mutu*
Hemba; Makutano, Kongolo, Zaire
Wood
H. 17.1 cm
Raymond and Laura Wielgus Collection
100.6.5.79

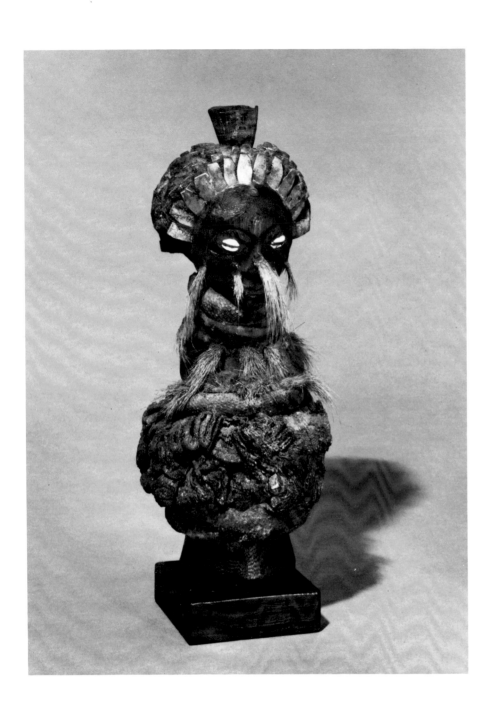

161
Figure
Songye; Zaire
Wood, iron, horn, fiber, snake skin,
animal hair, cowrie shells
H. 32 cm
74.55.3

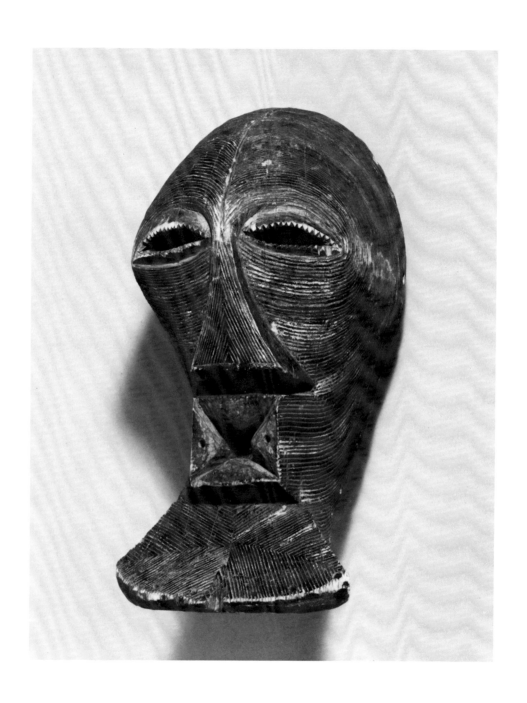

162
Mask, *kifwebe*
Songye; Zaire
Wood, pigment
H. 52.6 cm
75.54.3

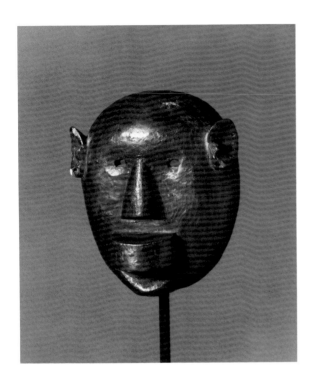

163
Mask
Makonde; Tanzania
Wood
H. 16.8
79.91

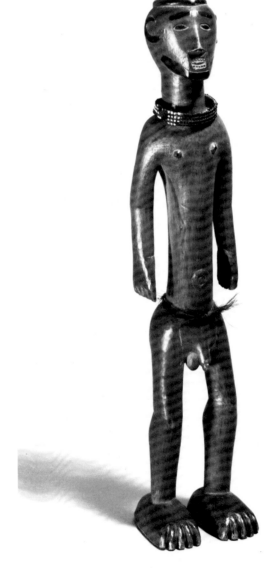

164
Figure
Nguni/Thonga (?); South Africa
Wood, glass beads, fiber, pigment
H. 44.2 cm
77.36